HUGH CARPENTER & TERI SANDISON

Hot Pasta

TEN SPEED PRESS

Berkeley, California

1❿

TEN SPEED PRESS
Post Office Box 7123
Berkeley, California 94707

Distributed in Australia by E. J. Dwyer Pty. Ltd., in Canada by Publishers Group West,
in New Zealand by Tandem Press, in South Africa by Real Books,
and in the United Kingdom and Europe by Airlift Books.

Cover and book design by Beverly Wilson.
Typography by Scott Woodworth.
Typefaces used in this book are Avant Garde, Futura, and Van Dijk.

Library of Congress Cataloging-in-Publication Data
Carpenter, Hugh
Hot Pasta/Hugh Carpenter and Teri Sandison
 p. cm.
Includes index.
ISBN 0-89815-857-5
1. Cookery (Pasta) I. Sandison, Teri II. Title.
TX809.M17C363 1996
641.8'22–dc20 96-16605
 CIP

Printed in Hong Kong

First printing, 1996

2 3 4 5 6 7 8 9 10—00 99 98 97

Dedicated to Jack and Dolores Cakebread,

whose legendary hospitality,

zest for life, and fine wines

have enriched so many lives.

Contents

Hot Pasta Night After Night

A passion for pasta is sweeping the land. Markets sell pastas shaped in spirals, shells, bow ties, radiators, little pens, corkscrews, and cartwheels. Pastas flavored with egg, spinach, tomato, and squid ink, are now widely available in dried and fresh form. You can create simple but delicious pasta recipes with fresh herbs, imported aged cheeses, and flavors from around the world. From top restaurant chefs cooking up complex dishes to infants spinning pasta across their high chairs, Americans from all walks of life are discovering that pasta deserves its reputation as the most creative, nutritious, economical, and convenient way to cook and eat. Pasta is quickly becoming America's favorite food.

In 1994, the United States surpassed Italy as the world's largest pasta consumer—3.96 versus 3.52 billion pounds. However, while Americans consume 19.8 pounds per person annually, the Italians eat an astounding 61.7 pounds per person a year. But we're gaining on them. In the United States, annual per capita consumption of pasta went from near zero in 1920 to 3.75 pounds by the end of that decade, and it has been rising at a rate of 5 percent annually ever since. The number of times per month Americans ate pasta rose 24 percent between 1984 and 1993, so that pasta has now become one of the top five foods consumed for dinner at home.

The recipes in this book use everyday equipment, simple preparation steps, common cooking techniques, and classic flavor combinations from around the world to highlight the marvelous flavor, texture, and color of pasta. While all the recipes use dried commercial wheat pasta made in America and Italy, you can follow the easy techniques for making homemade pasta (see page 86) and substitute it in the recipes in this book. For those who live near an Asian market, we also describe the most commonly found Asian pastas and explain how to substitute them for most of the dried pastas in this book.

Finally, on pages 54–56 you'll find a section for creating your own pasta recipes, including twelve wonderful pasta sauces to use as a starting point. We have enjoyed some of life's warmest moments while sharing wonderful-tasting pasta with family and friends. Join us in an exciting culinary adventure, and let pasta play a starring role in your kitchen night after night.

Hugh Carpenter and Teri Sandison

About Hot Pasta Recipes

- Be committed to flavor-intense, complex-tasting pasta dishes! Pasta is a nearly neutral-tasting main ingredient that depends on flavor-intense, top-quality ingredients to accent its subtle qualities. Always use fresh herbs, vine-ripened tomatoes, imported cheeses, the best olive oil, freshly ground black pepper, and the brands of condiments, seasonings, and spices listed in the Glossary. Use these guidelines and your pasta will taste stunning.

- The amount of pasta specified is always given in ounces rather than by volume. Pasta varies greatly in shape, making a uniform volume measurement for all pastas impossible.

- Each recipe will serve 4 people. All recipes allocate 2 ounces of dried pasta or 3 ounces of fresh pasta per person whether served as an entrée or a side dish. However, if your guests are known for their prodigious appetites, increase the amount of pasta by 1 ounce per person. If you do so, you will need to increase the amount of sauce slightly or adjust the seasonings during the final cooking steps.

- All recipes can be doubled or tripled, but the final procedure for combining the pasta with a sauce may have to be modified. In all recipes that call for adding the just-cooked pasta to a sauté pan containing the sauce, make the following simple adjustment: After boiling and draining the pasta, return the pasta to *the empty* pasta pot. Stir a little of the sauce into the pasta. Now ladle the pasta onto heated dinner plates and just top with the remaining sauce.

- All the recipes call for one of three types of dried pasta—two specific pastas and one of your choice. If you don't have one of the specific types of pasta listed in the recipe, use your favorite pasta or any one you have on hand. The dish will still taste delicious.

What could be easier than cooking pasta? Just bring a large amount of water to a rapid boil, cook the pasta until it reaches the al dente stage, then drain and toss the pasta with a delectable sauce or spoon the sauce over the top of the pasta. As simple as this may be, encyclopedic texts have been written about the mysteries of pasta cooking. Here's our contribution.

Perfectly Cooked Hot Pastas

1. Use a large pot that will be no more than three-quarters full after the water and pasta are added. This reduces the risk of messy "boil overs."

2. Fill the pot with cold water, not hot. Pasta lovers know that pasta tastes better cooked in water that was drawn cold from the tap. Use 4 quarts of water for every 8 ounces of dried or fresh pasta. A large amount of water is necessary to cook pasta evenly and prevent it from acquiring a starchy taste. If cooking more than 1 pound of dried or fresh pasta, use two pots. Home stoves don't generate enough heat to maintain more than 8 quarts of water at a rapid boil.

3. Place the pot of water over high heat and never lower the heat throughout the cooking process. Cover the pot so that the water comes to a boil faster.

4. Once the water is at a rapid boil, salt the water and immediately add the pasta. Lightly salting the water makes the boiling water boil faster and the pasta taste better. Unsalted pasta is bland no matter how flavorful the sauce. Add about 1 tablespoon salt to 4 quarts of boiling water. Never add oil to the water. Oil coats the pasta strands and makes it impossible for the sauce to cling to the cooked pasta.

5. Add the pasta to the rapidly boiling water all at once. Do not break long pieces of pasta in order to submerge them quickly. Just add the pasta and then gently press until the pasta is totally submerged.

6. Cover the pot so the water quickly returns to a boil. Then remove the cover and complete the cooking without covering the pot again. Stir the pasta to separate the strands and to promote even cooking.

7. If foam threatens to overflow the pot, add a splash of cold water. This breaks the surface tension and causes the foam to subside. You may have to do this several times, especially with Asian pasta, which has a heavy coating of flour and cornstarch. Also, rubbing a little oil around the top sides of the pot reduces the chances for boil overs.

8. Perfectly cooked pasta will have no raw color inside, and will be "firm to the bite," or as the Italians say, "*al dente*." Since the cooking times listed on packaged pasta are often too long, use them as a starting point. If in doubt, err on the side of undercooking. Remove a piece of pasta every minute and bite into it.

9. To rinse or not to rinse? If using the pasta for salads, rinse the pasta with cold water to wash off the starch and to stop the pasta from further cooking. When serving pasta hot, it should be rinsed only if a large amount of foam rose in the pot while the pasta cooked. If there is a large amount of foam (as is the case with most Asian wheat pastas), rinse the pasta briefly with the hottest tap water. Otherwise, the pasta will be starchy. If there is little or no foam (as is the

case with most dried American and Italian pastas), do not rinse the pasta. The small amount of starch still on the pasta helps thicken the sauce.

10. Don't overdrain pasta. Slightly wet pasta separates easily and the individual strands integrate more evenly with the sauce. To prevent pasta from sticking together, toss it with a little of the sauce immediately after draining.

11. The sauce can wait for the pasta, but the pasta never waits for the sauce. Because dried pasta takes 5 to 10 minutes to cook, most of the sauces for these recipes can be made while the pasta is boiling. However, if using fresh pasta, which cooks very quickly, finish the sauce before the fresh pasta enters the boiling water.

12. Serve the pasta dish immediately. Keeping a pasta dish hot and delaying serving it will result in a disappointing, overcooked mess.

Vegetarian Pastas from the Bounty of the Garden

There are so many exciting ways to integrate seasonal fresh vegetables and herbs with the more than 400 available pasta shapes. In this chapter the recipes range from a simple combination of pasta, fresh herbs, and Asian seasonings to a classic Italian pasta with olives, tomatoes, and artichokes. Try tossing pasta with extra virgin olive oil, chopped herbs, and grated cheese for a simple side dish. Another night you might sauté or stir-fry a generous amount of vegetables and then integrate them into the pasta for the main entrée. And don't limit your choices just to the recipes in this chapter, because all the seafood and meat pasta recipes taste great when converted into vegetarian pastas.

Key Pasta Techniques with Vegetables

For every 8 ounces of dried commercially made pasta, use 1 to 4 cups of vegetables. This will serve 4 people. Follow the outline for creating your own pasta recipes on page 54. Choose one of the eleven Master Pasta Recipes and prepare the sauce. Add the **seasonings**, and then sauté the vegetables following the directions below. When the vegetables brighten and are tender, add the **sauce** and pasta. Toss until evenly heated through. Add the **finishing touches** and serve.

Limit vegetables choices to no more than three per pasta dish. Otherwise, it is difficult to control the cooking times of the vegetables.

Cut the vegetables in the same shape and size as the pasta. For example, vegetables cut into matchstick-shaped pieces combine better with fettucine than vegetables cut into chunks.

Short-cooking vegetables: Sauté short-cooking vegetables just until their color brightens. Choices for short-cooking vegetables include thin asparagus, baby green beans, bok choy, Chinese longbeans, all cabbages, celery, very thinly cut Japanese eggplant, all mushrooms, all vegetables in the onion family, peas, all types of peppers and chiles, snow peas, and all types of summer squash.

Long-cooking vegetables: Sauté long-cooking vegetables first. When these turn a bright color, add the short-cooking vegetables. Choices for long-cooking vegetables include thick asparagus, broccoli, Brussels sprouts, carrots, and cauliflower.

Leafy vegetables such as spinach and arugula are great added to pasta dishes. Just sauté 2 to 6 cups of the greens in a little oil, and add the cooked pasta the moment they wilt.

Thai Primavera gains its special taste from the classic Thai flavor combinations of rich, sweet coconut milk, underlying currents of spicy chiles, sparkling citrus essence from freshly squeezed limes, and floral high-note tastes contributed by chopped basil and mint. From this basic flavor profile, many variations are possible. Replace the basil and mint with freshly chopped cilantro, substitute a chile sauce from a different part of the world or use finely minced fresh chiles, or omit the limes from the recipe and add 2 teaspoons of minced orange zest to the sauce.

Thai Primavera with Coconut, Chiles, and Lime

Serves 4 as a side dish

INGREDIENTS

8 ounces dried spaghetti, linguine, or your favorite pasta

¼ cup cooking oil

1 large carrot

1 sweet red pepper

1 yellow zucchini

3 whole green onions

½ pound small button mushrooms

20 small snow peas

SAUCE

¼ cup chopped basil leaves

¼ cup chopped mint leaves

2 tablespoons very finely minced ginger

2 cloves finely minced garlic

¾ cup unsweetened coconut milk

⅓ cup Chinese rice wine or dry sherry

2 tablespoons oyster sauce

1½ teaspoons Asian chile sauce

1 teaspoon cornstarch

2 limes

ADVANCE PREPARATION

Bring 4 quarts of water to a rapid boil. Lightly salt the water and cook the pasta according to the instructions on the package. When the pasta loses its raw taste but is still slightly firm, drain, rinse with cold water, and drain again. Toss the pasta with half of the cooking oil.

Cut the carrot into matchstick-shaped pieces about 1 inch long and ⅛ inch thick. Cut the red pepper, zucchini, and green onions into pieces the size of the carrots. Cut the button mushrooms into ⅛-inch-wide slices. Stem the snow peas and cut in half on a diagonal.

In a large bowl, toss the vegetables with the pasta until evenly mixed, then refrigerate. In a small bowl, combine all the ingredients for the sauce except the limes. Cut the limes into wedges and set aside. *All advance preparation steps may be completed up to 8 hours before you begin the final cooking steps.*

FINAL COOKING STEPS

Place a 12- or 14-inch sauté pan or a 14- or 16-inch flat bottom wok over highest heat. When the pan becomes hot, add the remaining 2 tablespoons cooking oil. When the oil becomes hot, add the pasta mixture. Stir and toss the pasta until it begins to become hot and the vegetables brighten, about 5 minutes.

Stir the sauce, and then add it to the pasta. Stir and toss the pasta. As soon as the pasta becomes hot, about 3 minutes, taste and adjust the seasonings. Transfer to a heated platter or 4 heated dinner plates. Serve at once accompanied by lime wedges to be squeezed over the pasta according to personal taste.

SUGGESTED ACCOMPANIMENTS

Barbecued swordfish with ginger-butter, arugula walnut salad, fresh peach tart

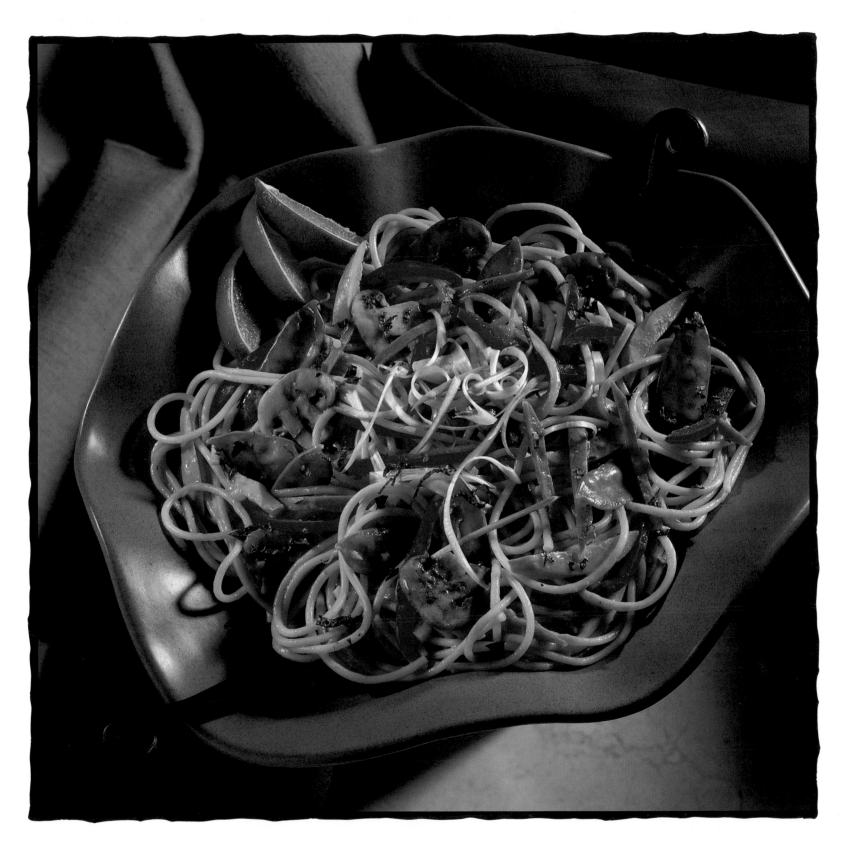

*F*ew recipes are easier or more appreciated than freshly cooked pasta tossed with homemade tomato salsa. Be sure to use vine-ripened tomatoes rather than the typical supermarket "cement" variety or canned tomatoes, which do not have the alluring tangy sweetness of fresh tomatoes. Luckily, high-quality, hothouse-grown tomatoes, sold with their stems attached, are increasingly available in supermarkets during the nonsummer months. In this recipe the tomatoes are roasted, which concentrates their sweetness.

Pasta with Roasted Tomato Salsa

Serves 4 as a side dish

SALSA

3 pounds vine-ripened tomatoes
½ cup chopped green onions
½ cup chopped cilantro sprigs
4 cloves garlic, finely minced
1 tablespoon very finely minced ginger
3 tablespoons red wine vinegar
1 tablespoon dark sesame oil
1 tablespoon flavorless cooking oil
1½ tablespoons sugar
2 teaspoons Asian chile sauce
½ teaspoon salt

INGREDIENTS

8 ounces dried fettucine, long fusilli, or your favorite pasta

ADVANCE PREPARATION

To make the salsa, preheat the oven to "broil." Cut the tomatoes into ½-inch-wide slices. Place the slices on a baking sheet and place approximately 4 inches from the heat. Broil the tomatoes until golden on top, about 3 minutes; then turn the tomatoes over and broil until golden, about 3 more minutes. Alternatively, cook the sliced tomatoes on an indoor grill pan or outdoor barbecue over medium heat.

When tomatoes are cooked, cool and then coarsely chop them. In a bowl, combine the tomatoes with the remaining salsa ingredients. Let rest at room temperature. *All advance preparation steps may be completed up to 8 hours before you begin the final cooking steps.*

FINAL COOKING STEPS

Bring 4 quarts of water to a rapid boil. Lightly salt the water, then cook the pasta according to the instructions on the package. When the pasta loses its raw texture but is still slightly firm, remove from the heat and drain.

Return the empty pasta pot to the stove over high heat. Add the salsa and bring to a boil. Immediately add the pasta. Stir and toss until evenly combined and well heated. Taste and adjust the seasonings, especially for salt. Transfer the pasta to a heated platter or 4 heated dinner plates. Serve at once.

SUGGESTED ACCOMPANIMENTS

Barbecued chicken with an ancho rub, avocado salad, and peach swirl ice cream

W e have served this rich-tasting pasta salad on picnics, as an appetizer, for buffets, and as the main entrée. There are two things to keep in mind when making this salad. First, use a top-quality peanut butter, either smooth or chunky, whose only ingredients are peanuts and salt. These peanut butters, without the preservatives, sugar, and shortening found in most supermarket brands, are more expensive, but they have a more intense, addictive peanut flavor. Second, be sure to bring the salad to room temperature before serving. The warmer temperature transforms the peanut dressing from being overly thick to a perfect creamy consistency.

Chinese Peanut Noodle Salad

Serves 4 as a side dish

INGREDIENTS

1 large carrot

1 bunch asparagus

8 ounces dried spaghetti, linguine, or your favorite pasta

2 red bell peppers, shredded

2 cups bean sprouts

2 tablespoons white sesame seeds, toasted

SALAD DRESSING

½ cup best-quality peanut butter

¼ cup red wine vinegar

3 tablespoons dark soy sauce

2 tablespoons dark sesame oil

1½ teaspoons sugar

2 teaspoons Asian chile sauce

¼ cup minced green onions

¼ cup chopped cilantro sprigs

2 tablespoons very finely minced ginger

ADVANCE PREPARATION

Cut the carrot on a sharp diagonal into ⅛-inch-wide slices; overlap the slices and cut the carrot into matchstick-shaped pieces about ⅛ inch wide and 1 inch long. Snap off and discard the tough asparagus ends. Cut the asparagus on a very sharp diagonal into 1-inch-long pieces. Bring 4 quarts of water to a rapid boil. Add the carrots and cook until they brighten, then immediately transfer them with a slotted spoon to a bowl of ice water. Add the asparagus to the boiling water and cook until they brighten, about 30 seconds, then immediately transfer them to the bowl containing the carrots. When the carrots and asparagus are chilled, drain and pat dry.

Return the water to a boil. Lightly salt the water, then cook the pasta according to the instructions on the package. When the pasta loses its raw texture but is still slightly firm, remove from the heat, drain, rinse with cold water, and drain again.

Set aside the peppers, bean sprouts, and sesame seeds. To make the salad dressing, in a bowl, whisk together the peanut butter and ⅔ cup boiling water, mixing thoroughly. Add all the remaining ingredients and mix well. In a large mixing bowl, combine the pasta with all the vegetables, including the peppers and bean sprouts, and dressing. Stir and toss until evenly combined. Refrigerate if assembled more than 1 hour before serving. *All advance preparation steps may be completed up to 8 hours before serving the salad.*

FINAL STEPS

Bring the salad to room temperature. Toss the salad to evenly combine. Taste and adjust the seasonings. Place on a platter, dinner plates, or salad plates. Sprinkle with sesame seeds and serve.

SUGGESTED ACCOMPANIMENTS

Barbecued pork baby back ribs, white corn with herbed butter, and chocolate layer cake

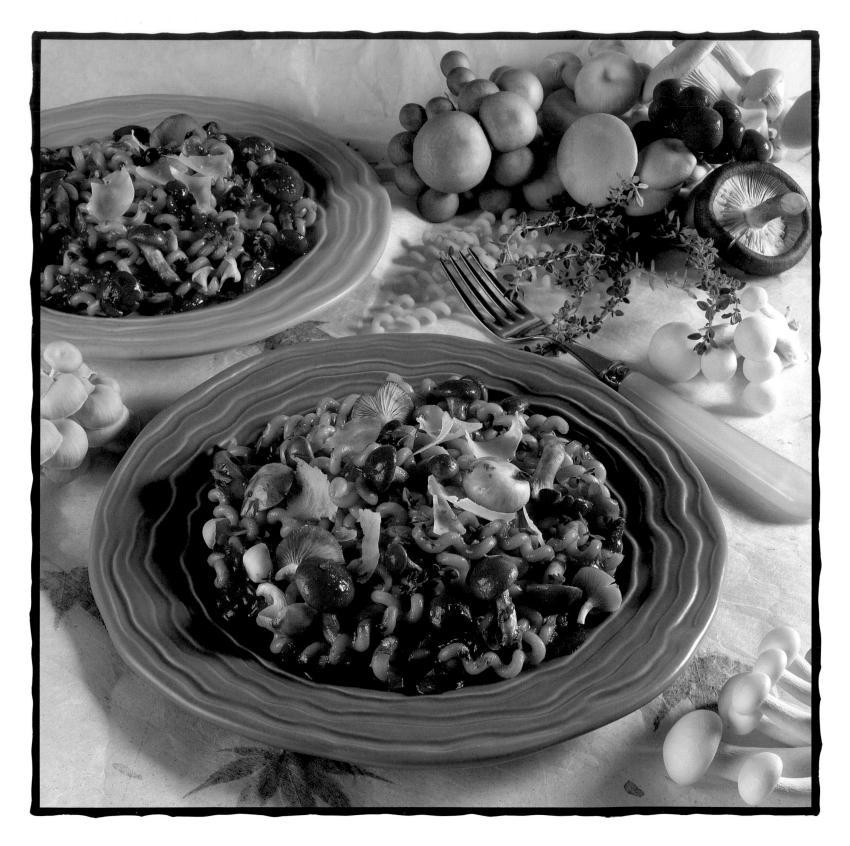

The flavor secret in this recipe is to sauté the thinly sliced fresh mushrooms until they lose nearly all their moisture. Once they have shrunk and become dense, a rich tomato-herb sauce is added. The tiny amount of cream stirred in at the last minute contributes a wonderful richness. Choose only the firm-fleshed varieties of mushrooms, and not enoki or oyster mushrooms whose soft texture does nothing to enhance this recipe. Although common button mushrooms work fine in this recipe, including a few of the more exotic mushrooms elevates the dish from simple to sublime.

Wild Mushroom Pasta

Serves 4 as a side dish

INGREDIENTS

⅓ cup unsalted butter

4 cloves garlic, finely minced

¼ cup minced shallots

1 pound assorted fresh mushrooms (shiitakes, portobellos, and chanterelles)

4 ounces Reggiano Parmesan cheese

½ cup parsley sprigs

1 tablespoon cornstarch

2 tablespoons heavy cream

8 ounces dried short fusilli, bow ties, or your favorite pasta

SAUCE

1 cup vegetable or chicken stock

2 tablespoons oyster sauce

2 teaspoons tomato paste

½ teaspoon sugar

¼ cup shredded basil leaves

1 teaspoon minced thyme sprigs

ADVANCE PREPARATION

In a small bowl, combine the butter, garlic, and shallots. If the mushrooms appear dirty, wipe them with damp paper towels. Cut off the shiitake and portobello stems.

Cut the mushrooms into ⅛-inch-thick slices and set aside. Set aside the cheese, parsley, cornstarch, cream, and pasta. In a bowl, combine all the sauce ingredients. *All advance preparation steps may be completed up to 8 hours before you begin the final cooking steps.*

FINAL COOKING STEPS

Shave the cheese, about ¾ cup. Chop the parsley. Combine the cornstarch with 1 tablespoon cold water. Bring 4 quarts of water to a rapid boil. Lightly salt the water, then cook the pasta according to the instructions on the package. When the pasta loses its raw texture but is still slightly firm, remove from the heat and drain.

Meanwhile, place a 12- or 14-inch sauté pan over high heat. Add the butter mixture and sauté until the garlic begins to sizzle but has not browned. Add the

mushrooms and sauté until they absorb the butter. Reduce the heat to medium and sauté until the mushrooms wilt, about 5 minutes. Add the sauce.

Add the pasta. Stir and toss until evenly combined and well heated. Add just enough of the cornstarch mixture so the sauce forms a thin glaze on the pasta. Stir in the cream and half the cheese. Taste and adjust the seasonings, especially for salt. Transfer the pasta to a heated platter or 4 heated dinner plates. Sprinkle on the parsley and the remaining cheese. Serve at once.

SUGGESTED ACCOMPANIMENTS

Cold rare roast beef with a horseradish sauce, a fava bean salad, and an apple crisp

Necessary Cookware for Hot Pasta

Pasta pots: Pasta pots range in size from 6 to 12 quarts. If you're unsure which size to purchase, pick a larger pot because it will be big enough to cook a double portion of pasta. We prefer the heavy Calphalon pasta pots because their even heat distribution enables us to maintain a rapid boil. Moreover, many of the recipes call for cooking a simple pasta sauce in the emptied pasta pot, and then returning the pasta to the pot for a quick saucing. The heavy Calphalon pasta pot works great for this; thin-gauged stainless steel pasta pots will warp and cook the sauce unevenly.

Pasta inserts: These wonderful, perforated pasta pot liners allow you to quickly drain the pasta without transferring the pasta to a colander. Once the pasta is cooked, lift out the pasta insert, tip it to one side, and then balance it on the top of the pasta pot. Steam rising from the boiling water keeps the pasta hot while the pasta drains.

Sauté pans and woks: Recipes in this book use a 12- to 14-inch sauté pan for combining pasta with many of the sauces. If both pans are available, choose the biggest one. Eight ounces of pasta, cooked and combined with the sauce in a 12-inch sauté pan, is a very tight fit! A 16-inch wok also works well. For a simple alternative technique to combining pasta with a sauce, see page 9.

Wooden pasta forks and metal tongs: Wooden pasta forks are the best implements for mixing pasta evenly with a sauce. We think they also work better than the plastic pronged pasta ladles for transferring pasta and sauce from platter to plate. If the pasta has plenty of sauce, add extra sauce with a regular spoon. Restaurant-quality metal tongs, with their rippled edges, also work well for transferring pasta.

Chinese soup ladle: A shallow 1-cup Chinese soup ladle is the most efficient way to quickly transfer all the short pastas from sauté pan or colander to dinner plate, and for spooning sauces onto pasta.

Electric mini-chopper: Small electric mini-choppers mince shallots, garlic, ginger, and fresh chiles far more quickly than a knife. A full-sized food processor bowl is too big for these tasks. However, don't mince fresh herbs in the mini-chopper. They quickly blacken and become mushy. Best brands: Krups, Cuisinart, and Mouli.

Garlic Press: A good garlic press eliminates the need to peel garlic or to mince ginger. There is only one good garlic press made, the Zyliss/Susi garlic press.

Zester: This fantastic tool makes removing the outside colored skin of citrus fruits easy. However, there are many poorly designed zesters. The top-quality zesters are made by the European knife manufacturers, such as Henckles.

Cheese grater: Sturdy cheese graters sold at cookware shops are far easier to use than their flimsy supermarket cousins. There are also very good rotary cheese graters designed to easily grate hard cheeses.

Pasta machine: We prefer the hand-cranked machines such as those made by Atlas and Imperia. Buy the kind that produces the widest sheets of pasta so that the pasta-making process takes less time to complete. The expensive electric attachment is noisy and does not speed the pasta-making process. We do not recommend electric pasta machines that knead and extrude the dough because they make a dense-textured, tough pasta.

Dough scrapers: Used to keep work surfaces clean and to move or transfer pasta sheets. Metal dough scrapers work better than plastic ones.

Cutting implements: Wheel cutters with rippled edges, used for cutting pasta dough.

Baby artichokes, with their mild grassy-nutty taste and exotic look, are a great addition to pasta dishes. After a short preliminary cooking, it takes little time to remove the tiny thistle from the center and the tough outer leaves. Baby artichokes are much easier to use than the more readily available mature artichokes with their many tough outer leaves and thick interior thistle. Frozen artichoke hearts are an acceptable substitute, but if you substitute bottled marinated artichoke hearts, rinse them with water to lessen their sour taste.

Pasta with Olives, Tomatoes, and Artichokes

Serves 4 as a side dish

INGREDIENTS

¼ cup extra virgin olive oil

5 cloves garlic, finely minced

¼ cup minced shallots

14 fresh baby artichokes

¼ pound low-brine black European olives, pitted

¼ pound fennel root with tops

1 cup seeded and chopped vine-ripened tomatoes

1 teaspoon minced lemon zest

2 tablespoons freshly squeezed lemon juice

1 teaspoon salt

½ teaspoon crushed red pepper flakes

3 ounces pecorino or Reggiano Parmesan cheese

8 ounces dried fettucine, linguine, or your favorite pasta

ADVANCE PREPARATION

In a small bowl, combine the olive oil, garlic, and shallots. Bring 2 quarts of water to a boil. Trim away the top inch from each artichoke. Place the artichokes in the boiling water, cover, reduce the heat to low, and simmer 20 minutes. Remove the artichokes from the water and let cool. When cool enough to handle, discard all the tough outer leaves and trim the tops. Cut the artichokes in half and discard the thistles. If done more than 15 minutes in advance, rub the artichokes with lemon juice to prevent them from discoloring or submerge them in a mixture of cold water and 2 tablespoons of lemon juice, vinegar, or ascorbic acid.

Cut the olives in half lengthwise. Shred the fennel root and chop the green fennel tops. In a separate bowl, combine the tomatoes, olives, and fennel and its top. Combine the minced lemon zest, lemon juice, salt, and pepper flakes. *All advance preparation steps may be completed up to 8 hours before you begin the final cooking steps.*

FINAL COOKING STEPS

Grate the cheese, about ¾ cup. If artichokes are submerged in water, drain. Bring 4 quarts of water to a rapid boil. Lightly salt the water, then cook the pasta according to the instructions on the package. When the pasta loses its raw texture but is still slightly firm, set aside ½ cup of the pasta water, then remove from the heat and drain.

Return the empty pasta pot to the stove over high heat. Add the olive oil, garlic, and shallots and sauté until the garlic begins to sizzle but has not browned. Add the tomatoes, olives, fennel, and artichokes. Sauté until the tomatoes and artichokes are well heated, about 3 minutes. Add the pasta, lemon juice mixture, and reserved pasta water. Stir and toss until evenly combined and well heated.

Add the grated cheese. Taste and adjust the seasonings, especially for salt and spice. Transfer the pasta to a heated platter or 4 heated dinner plates. Serve at once.

SUGGESTED ACCOMPANIMENTS

Cold poached salmon with a Cajun-style tartar sauce, Caesar salad, and Grand Marnier chocolate ice cream

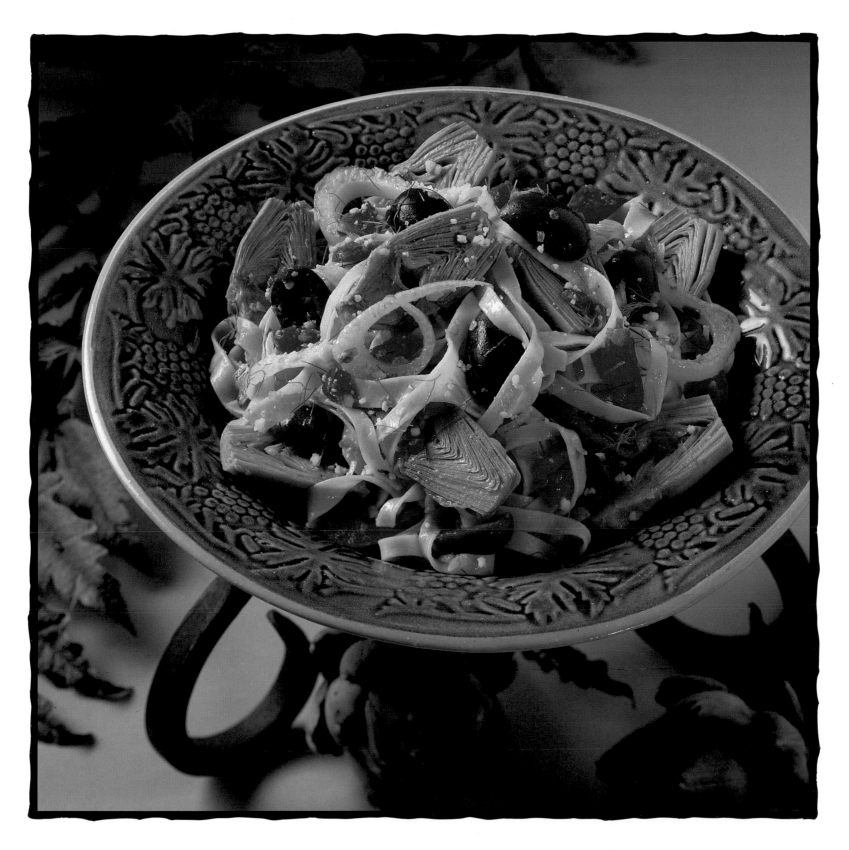

*P*asta is the perfect platform on which the flavors of the world can star. Virtually any of your favorite sauces or any popular flavor blend from the world's primary cuisines work well when combined with Italian or Asian pasta. In this Indian-style pasta recipe, the flavors of curry powder, mint, oyster sauce, and ginger create an exciting multidimensional dish. If you can find Indian curry paste, which has a far more intense curry taste than the powder form, use it but reduce the amount by half.

Indian Curried Pasta

Serves 4 as a side dish

INGREDIENTS

1 large carrot

4 small Japanese eggplant

12 button mushrooms

5 whole green onions

1 cup dark raisins

8 ounces dried fettucine, linguine, or your favorite pasta

SAUCE

3 tablespoons flavorless cooking oil

3 cloves garlic, finely minced

2 tablespoons very finely minced ginger

2 tablespoons curry powder

1 cup unsweetened coconut milk

½ cup vegetable or chicken stock

¼ cup Chinese rice wine or dry sherry

2 tablespoons oyster sauce

1 tablespoon dark sesame oil

1 teaspoon Asian chile sauce (optional)

½ cup chopped basil leaves or cilantro sprigs

ADVANCE PREPARATION

Cut the carrot into matchstick-shaped pieces about 1 inch long and ⅛ inch thick. Cut the eggplant crosswise into ¼-inch-thick slices. Thinly slice the mushrooms. Cut the green onions on a diagonal into 1-inch lengths. In separate containers, set aside the raisins and pasta.

To make the sauce, combine the oil, garlic, ginger, and curry powder. In a separate container, combine all the remaining sauce ingredients. Refrigerate. *All advance preparation steps may be completed up to 8 hours before you begin the final cooking steps.*

FINAL COOKING STEPS

Bring 4 quarts of water to a rapid boil. Lightly salt the water, then cook the pasta according to the instructions on the package. When the pasta loses its raw texture but is still slightly firm, remove from the heat and drain.

Meanwhile, place a 12- or 14-inch sauté pan over high heat. When hot, add the oil-garlic mixture and sauté until the garlic begins to sizzle but has not browned. Add the carrot, eggplant, mushrooms, and ½ cup water. Cover the pan and steam the vegetables until the eggplant soften, about 2 minutes. Add the green onions and raisins. Stir and toss until the green onions brighten, about 1 minute.

Add the pasta and the sauce. Stir and toss until evenly combined and well heated. Taste and adjust the seasonings, especially salt. Transfer the pasta to a heated platter or 4 heated dinner plates. Serve at once.

SUGGESTED ACCOMPANIMENTS

A tomato and cucumber salad, chilled shrimp, and a chocolate nut torte.

This was a delicious and quick creation we made one night after we had bought chanterelle mushrooms at half price in our local supermarket. Since that night, we have substituted fresh portobellos, morels, shiitakes, and even common button mushrooms with very good results. The mushrooms are sautéed in a little butter over low heat for 15 to 20 minutes, which intensifies their flavor and firms their texture.

Pasta with Chanterelles, Parsley, and Garlic

Serves 4 as a side dish

INGREDIENTS

¼ cup butter

4 cloves garlic, finely minced

12 ounces fresh chanterelle mushrooms

5 whole green onions

8 ounces dried egg fettucine, linguine, or your favorite pasta

½ cup chopped parsley

½ to 1 teaspoon salt

½ teaspoon freshly ground black pepper

1 lemon, cut into wedges

2 ounces pecorino or Reggiano Parmesan cheese

ADVANCE PREPARATION

In a small bowl, combine the butter and garlic. Wipe the chanterelles with damp paper towels, then thinly slice. Cut the green onions on a sharp diagonal into 1-inch lengths and set aside with the mushrooms. *All advance preparation steps may be completed up to 8 hours before you begin the final cooking steps.*

FINAL COOKING STEPS

Set aside the pasta, parsley, salt, pepper, and lemon. Grate the cheese, about ½ cup. Place a 12- or 14-inch sauté pan over medium heat. When hot, add the butter and garlic and sauté until the garlic begins to sizzle but has not browned. Add the mushrooms and onions. Reduce the heat to low. Every 2 to 3 minutes, stir and toss the mushroom slices until they shrink drastically in size, about 15 to 20 minutes.

When the mushrooms are nearly cooked, bring 4 quarts of water to a rapid boil. Lightly salt the water, then cook the pasta according to the instructions on the package. When the pasta loses its raw texture but is still slightly firm, set aside ½ cup of the pasta water, then remove from the heat and drain.

Transfer the pasta to the sauté pan. Sprinkle on the parsley, salt, pepper, and the ½ cup pasta water. Stir and toss until evenly combined and well heated. Taste and adjust the seasonings, especially for salt and pepper. Transfer the pasta to a heated platter or 4 heated dinner plates. Sprinkle with cheese. Serve at once, accompanied by the lemon wedges.

SUGGESTED ACCOMPANIMENTS

A veal meatloaf brushed with an Asian-style barbecue sauce, spinach salad, and cherry pie with ice cream

G rilled vegetables are wonderful in pasta dishes. This recipe provides a Southwest-style marinade, but any vinaigrette salad dressing works perfectly, brushed across the vegetables during barbecuing. The vegetables can be grilled and cut hours ahead, thus making the final assembly very easy. The special ingredient for this recipe, chipotle chiles in adobo sauce, is sold in 4-ounce cans at most supermarkets, but you can substitute a spicy tomato-based chile sauce if you prefer.

Southwest Pasta with Grilled Vegetables

Serves 4 as a side dish

MARINADE

½ cup white wine

⅓ cup extra virgin olive oil

⅓ cup freshly squeezed lime juice

¼ cup thin soy sauce

2 tablespoons canned chipotle chiles in adobo, minced

2 tablespoons light brown sugar

1 teaspoon ground cumin seeds

⅓ cup chopped cilantro sprigs

4 cloves garlic, finely minced

INGREDIENTS

½ pound cauliflower

12 asparagus spears

4 carrots

2 yellow zucchini

1 red onion

4 ounces goat cheese

½ cup cilantro sprigs

¼ cup toasted pumpkin seeds, for garnish

8 ounces dried bow ties, penne, or your favorite pasta

2 tablespoons extra virgin olive oil

ADVANCE PREPARATION

In a small bowl, combine all the marinade ingredients. Cut the cauliflower, asparagus, carrots, zucchini, and red onion into large pieces for grilling and place in a large bowl. Stir the marinade, then pour over the vegetables. Toss the vegetables until well coated with the marinade. Marinate for 1 hour unrefrigerated.

Grill the vegetables over medium heat on an outdoor gas or charcoal barbecue, or on an indoor grill pan until they soften slightly and acquire light grill marks. During cooking, brush a little more marinade over the vegetables. When done, cut the vegetables into 1-inch-wide slices. Refrigerate. Reserve the remaining marinade. *All advance preparation steps may be completed up to 8 hours before you begin the final cooking steps.*

FINAL COOKING STEPS

Crumble the goat cheese. Chop the cilantro. Set aside the pumpkin seeds. Bring 4 quarts of water to a rapid boil. Lightly salt the water, then cook the pasta according to the instructions on the package. When the pasta loses its raw texture but is still slightly firm, remove from the heat and drain.

Return the empty pasta pot to the stove over high heat. Add the 2 tablespoons of olive oil. When the oil becomes hot, add the grilled vegetables. Stir and toss until reheated. Add the pasta and reserved marinade. Stir and toss until evenly combined and well heated. Taste and adjust the seasonings, especially for salt. Transfer to a heated platter or 4 heated dinner plates. Sprinkle on the goat cheese, cilantro, and pumpkin seeds. Serve at once.

SUGGESTED ACCOMPANIMENTS

Roast tenderloin of pork with a Southwest-style rub, a sliced tomato salad, and bittersweet chocolate ice cream

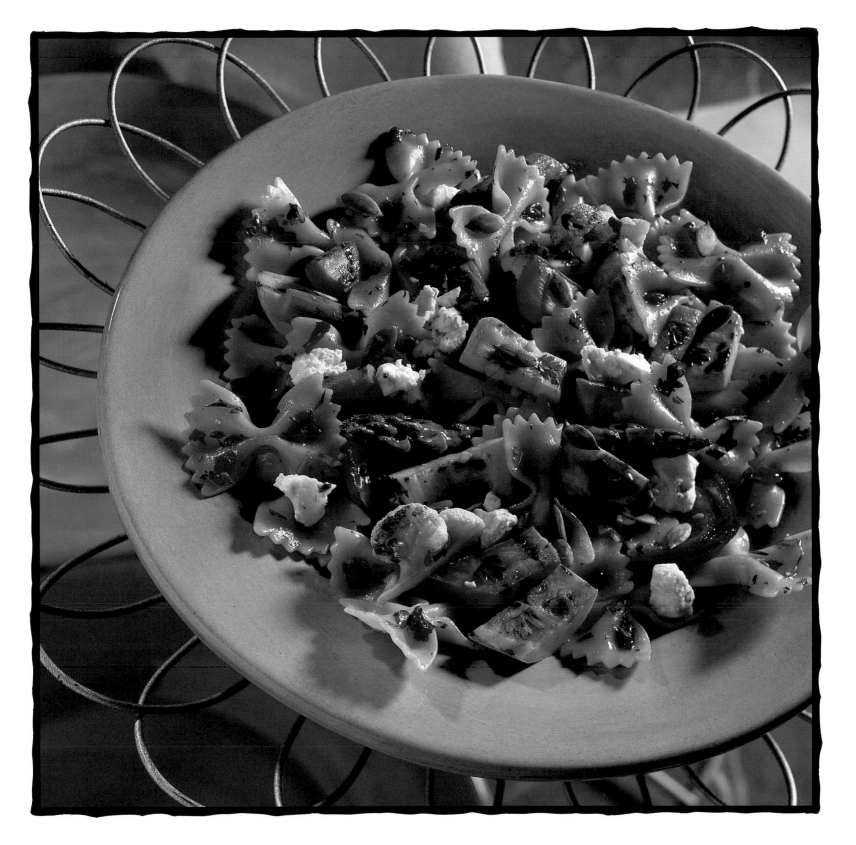

This is one of the easiest recipes in the book. Once the pasta is cooked and drained, a simple Asian seasoning blend is heated in the hot pasta pot, and then the pasta is simply returned to the pot and tossed with all the flavor-intense ingredients. During the few minutes that it takes to evenly combine everything, taste the pasta and adjust the seasonings, especially for soy sauce, rice vinegar, sesame oil, and chile sauce. Although this recipe uses linguine, other pastas such as penne or fusilli work wonderfully.

Pasta with Tangerine, Garlic, and Sesame

Serves 4 as a side dish

INGREDIENTS

2 tablespoons flavorless cooking oil

4 cloves garlic, finely minced

1 tablespoon very finely minced ginger

2 teaspoons finely minced lemon zest

2 teaspoons finely minced tangerine or
 orange zest

2 tablespoons white sesame seeds

8 ounces dried linguine, spaghetti, or
 your favorite pasta

SAUCE

¼ cup minced chives

½ cup chopped cilantro sprigs

¼ cup freshly squeezed tangerine or
 orange juice

2 tablespoons unseasoned rice vinegar

2 tablespoons thin soy sauce

2 tablespoons light brown sugar

1 tablespoon dark sesame oil

2 teaspoons Asian chile sauce

ADVANCE PREPARATION

In a small container, combine the oil, garlic, ginger, and lemon and tangerine zest, and set aside. Place the sesame seeds in an ungreased sauté pan and toast until golden. In a small bowl, combine all the sauce ingredients and set aside. *All advance preparation steps may be completed up to 8 hours before you begin the final cooking steps.*

FINAL COOKING STEPS

Bring 4 quarts of water to a rapid boil. Lightly salt the water, then cook the pasta according to the instructions on the package. When the pasta loses its raw texture but is still slightly firm, remove from the heat and drain.

Return the empty pasta pot to the stove over medium-high heat. Add the oil-garlic mixture and sauté until the garlic begins to sizzle but has not browned. Add the sauce and bring to a rapid boil.

Add the pasta and sesame seeds. Stir and toss until evenly combined and well heated. Taste and adjust the seasonings, especially for salt. Transfer the pasta to a heated platter or 4 heated dinner plates. Serve at once.

SUGGESTED ACCOMPANIMENTS

Pork chops, Cobb salad, and a walnut fudge cake

O ne of the most exciting aspects of using Asian seasonings is the alluring range of flavors they contribute. In this pasta dish, which highlights garden-fresh vegetables, the nutty-tasting dark sesame oil and deeply flavored oyster sauce contribute lingering low notes, while the vinegar, chile sauce, and minced orange zest add varying levels of sparkling high notes.

East-West Pasta with Citrus Accents

Serves 4 as a side dish

INGREDIENTS

8 ounces dried spaghetti, linguine, or your favorite pasta

1 tablespoon flavorless cooking oil

2 large carrots

¼ pound red cabbage

2 cups sugar snap peas or snow peas

2 cups bean sprouts

SAUCE

3 tablespoons flavorless cooking oil

4 cloves garlic, finely minced

2 tablespoons very finely minced ginger

¾ cup vegetable or chicken stock

3 tablespoons Chinese rice wine or dry sherry

2 tablespoons dark sesame oil

2 tablespoons oyster sauce

1 tablespoon red wine vinegar

1 tablespoon cornstarch

1 teaspoon Asian chile sauce

½ teaspoon sugar

2 teaspoons finely minced orange zest

ADVANCE PREPARATION

Bring 4 quarts of water to a rapid boil. Lightly salt the water, then cook the pasta according to the instructions on the package. When the pasta loses its raw texture but is still slightly firm, drain, rinse with cold water, and drain again. Transfer to a bowl and toss with 1 tablespoon of cooking oil.

Peel the carrots. Cut the carrots on a very sharp diagonal in ⅛-inch-wide slices; overlap the slices and cut into matchstick-shaped pieces about ⅛ inch wide and 1 inch long. Shred the cabbage, about 2 cups. Add the carrots, cabbage, snap peas, and bean sprouts to the pasta, mix until evenly combined, then refrigerate.

To make the sauce, in a small bowl, combine the cooking oil, garlic, and ginger, and set aside. In a separate bowl, combine all the remaining sauce ingredients, stir well, and refrigerate. *All advance preparation steps may be completed up to 8 hours before you begin the final cooking steps.*

FINAL COOKING STEPS

Stir the sauce. Place a 14-inch wok or 12-inch sauté pan over high heat. When hot, add the oil-garlic mixture and sauté until the garlic begins to sizzle but has not browned. Add the pasta and the sauce. Stir and toss until evenly combined and well heated. Taste and adjust the seasonings. Transfer the pasta to a heated platter or 4 heated dinner plates. Serve at once.

SUGGESTED ACCOMPANIMENTS

Barbecued pork tenderloin brushed with hoisin sauce, a jicama salad, and passion fruit sorbet

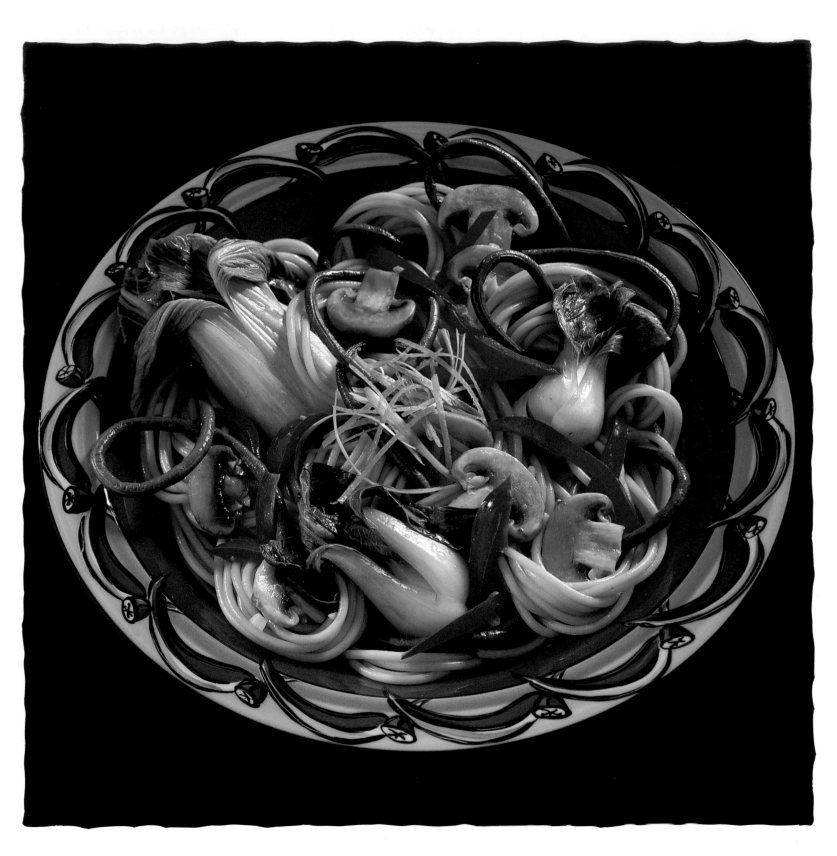

L o mein, or "soft noodles," are cold noodles that are stir-fried with matchstick-cut vegetables until piping hot. They are much easier to prepare than the other Chinese classic chow mein, or "two-side noodles," which are panfried noodles topped with a stir-fry dish. Although the following recipe provides a traditional Cantonese sauce to flavor the dish, we diverge from tradition by keeping the baby bok choy whole. Try varying the flavor by substituting any stir-fry sauce, such as the Thai coconut herb sauce from Thai Primavera with Coconut, Chiles, and Lime (page 14) or the hoisin-cilantro-chile sauce from Angel Hair Pasta with Duck (page 81).

California Lo Mein

Serves 4 as a side dish

INGREDIENTS

8 Chinese longbeans or 1 cup baby green beans

4 baby bok choy, or 5 large bok choy stalks

8 ounces dried spaghetti, linguine, or your favorite pasta

¼ cup flavorless cooking oil

4 cloves garlic, finely minced

2 tablespoons very finely minced ginger

2 red bell peppers, cut into 1-inch shreds

12 small button mushrooms, thinly sliced

3 whole green onions, shredded

1 tablespoon julienned orange zest

SAUCE

⅓ cup Chinese rice wine or dry sherry

3 tablespoons oyster sauce

2 tablespoons dark sesame oil

1 tablespoon hoisin sauce

1 teaspoon Asian chile sauce (optional)

½ teaspoon minced orange zest

ADVANCE PREPARATION

Cut the longbeans into 1-inch lengths. If you want to keep the baby bok choy whole, combine with the longbeans. Drop the longbeans and whole baby bok choy into 4 quarts of rapidly boiling water and cook until they brighten. Transfer to ice water, and when chilled, drain and pat dry. Keep the water at a boil. Cook the pasta according to the instructions on the package. When the pasta loses its raw texture but is still slightly firm, remove from heat, drain, rinse with cold water, and drain again. Toss the pasta with 2 tablespoons of the cooking oil.

Combine the remaining oil with the garlic and ginger. If you do not want to leave the cooked bok choy whole, separate the stems and cut into bite-sized pieces. If using large bok choy, cut them on a sharp diagonal into ¼-inch-wide strips, including the leafy tops. Toss all the vegetables with the pasta until evenly mixed, and refrigerate. Set aside the julienned orange zest (refrigerate if not using immediately). In a small bowl, combine all the ingredients for the sauce. *All advance preparation steps may be completed up to 8 hours before you begin the final cooking steps.*

FINAL COOKING STEPS

Place a 12- or 14-inch sauté pan or a 14- or 16-inch flat bottom wok over high heat. When the pan becomes hot, add the oil-garlic mixture. When the oil becomes very hot, add the pasta. Stir and toss the pasta until it becomes hot and the vegetables brighten, about 4 minutes. Add the sauce. When the pasta is well heated, taste and adjust the seasonings. Transfer to a heated platter or 4 heated dinner plates and garnish with the orange zest. Serve at once.

SUGGESTED ACCOMPANIMENTS

Barbecued halibut, an avocado and papaya salad, and a flourless chocolate cake

PAPPARDELLE
wide ribbons

FUSILLI/ROTELLE
springs (both short & long)

Nearly all the recipes in this book use dried wheat pastas that are common in Italy and the United States. These dried pastas work beautifully whether used for authentic Italian recipes, contemporary cross-cultural pasta creations, or a substitute in authentic Asian pasta recipes.

Hot Pasta from Italy and America

LASAGNA
very wide pasta sheets

Not all durum wheat is alike in hardness or quality. The blend of durum wheat and the process the manufacturer uses to make and dry the dough determine the firmness of the cooked pasta, its color, and how well sauces cling to the pasta surface. In Italy, there are strict laws governing pasta manufacturing, including the requirement that only semolina can be used. No such regulations exist for American pasta manufacturers. Fortunately, many manufacturers in the United States make good pasta, and we have found all the dried Italian pasta to be of uniform high quality.

Avoid flavored dried pastas. Who conceived the idea for dried chocolate, saffron, lemon-herb, and lobster pasta? Let some other consumer buy these poorly flavored, expensive pastas. Likewise, avoid the so-called "fresh" pasta made by well-known food manufacturers. Their products, displayed in refrigerated

RUOTE DI CARRO
cartwheels

CONCHIGLIE
shells

LINGUINE
little tongues

CAVATAPPI
corkscrews

ORZO
pasta grains the size of rice

CAPELLI D'ANGELO
angel hair

FETTUCCINE
little ribbons

PENNE
pens

GNOCCHI
similar in shape to potato dumplings

cases at supermarkets across the nation, are thick, densely textured, stale-tasting gastronomic flops. Buy commercially made fresh pasta only if it is made by a small local company with an established reputation for its excellent product. On pages 86–87, we show you how to substitute marvelous-tasting, homemade pasta in place of dried pastas.

The following commercial dried pastas work beautifully, whether for authentic Italian recipes or contemporary cross-cultural pasta creations, or as a substitute in authentic Asian pasta recipes. There are over 400 different pasta shapes to choose from. Consider the following list of pastas a starting point and experiment with the many other available shapes.

SPAGHETTI
little strings

RADIATORE
little radiators

FARFALLE
bow ties or butterflies

MACARONI
elbows

Here, slices of eggplant and peppers are marinated, grilled, and then combined with pasta, toasted walnuts, and basil. A key technique is to marinate the sliced eggplant 30 to 60 minutes. When marinated for fewer minutes, the eggplant does not absorb enough flavor; when marinated for more than 1 hour, it becomes mushy.

Mediterranean Pasta with Eggplant and Peppers

Serves 4 as a side dish

INGREDIENTS

1 cup raw walnut halves

8 ounces dried cartwheel, fusilli, or your favorite pasta

2 ounces Asiago or Reggiano Parmesan cheese

3 bell peppers

4 Japanese eggplant or 1 globe eggplant

2 tablespoons extra virgin olive oil

4 sprigs basil (optional)

MARINADE

¼ cup extra virgin olive oil

½ cup chicken stock

1 tablespoon minced lemon zest

2 tablespoons freshly squeezed lemon juice

6 cloves garlic, finely minced

½ cup chopped parsley sprigs

¼ cup chopped basil leaves

1 tablespoon red peppercorns

1 teaspoon Asian chile sauce

½ teaspoon salt

ADVANCE PREPARATION

Preheat the oven to 325°. Toast the nuts for 15 minutes. In separate containers, set aside the pasta and cheese.

Stem and seed the peppers, then cut into 2-inch-wide strips. Stem the eggplant, then cut lengthwise into ¼-inch-wide slices. Place the vegetables in a large bowl. In separate containers, set aside the 2 tablespoons of olive oil and the basil sprigs. In a small bowl, combine all the ingredients for the marinade. Stir the marinade, then pour over the vegetables. Toss the vegetables until well coated with the marinade. Marinate 30 to 60 minutes at room temperature.

Grill the vegetables over medium heat on an outdoor gas or charcoal barbecue, or on an indoor grill pan until they soften slightly and acquire light grill marks. During cooking, brush a little marinade over the vegetables. When done, cut the vegetables into 1-inch-wide pieces. Refrigerate. Save the remaining marinade. *All advance preparation steps may be completed up to 8 hours before you begin the final cooking steps.*

FINAL COOKING STEPS

Grate the cheese, about ½ cup. Cut the basil sprigs into slivers and sprinkle over pasta. Bring 4 quarts of water to a rapid boil. Lightly salt the water, then cook the pasta according to the instructions on the package. When the pasta loses its raw texture but is still slightly firm, remove from the heat and drain.

Return the empty pasta pot to the stove over high heat. Add the reserved 2 tablespoons olive oil. When the oil becomes hot, add the grilled vegetables and cook until reheated. Add the marinade, pasta, walnuts, and the cheese. Stir and toss the pasta until evenly combined and well heated. Taste and adjust the seasonings, especially for salt. Transfer the pasta to a heated platter or 4 heated dinner plates. Serve at once.

SUGGESTED ACCOMPANIMENTS

Roast butterflied leg of lamb, a watercress salad, and fresh berries with cream

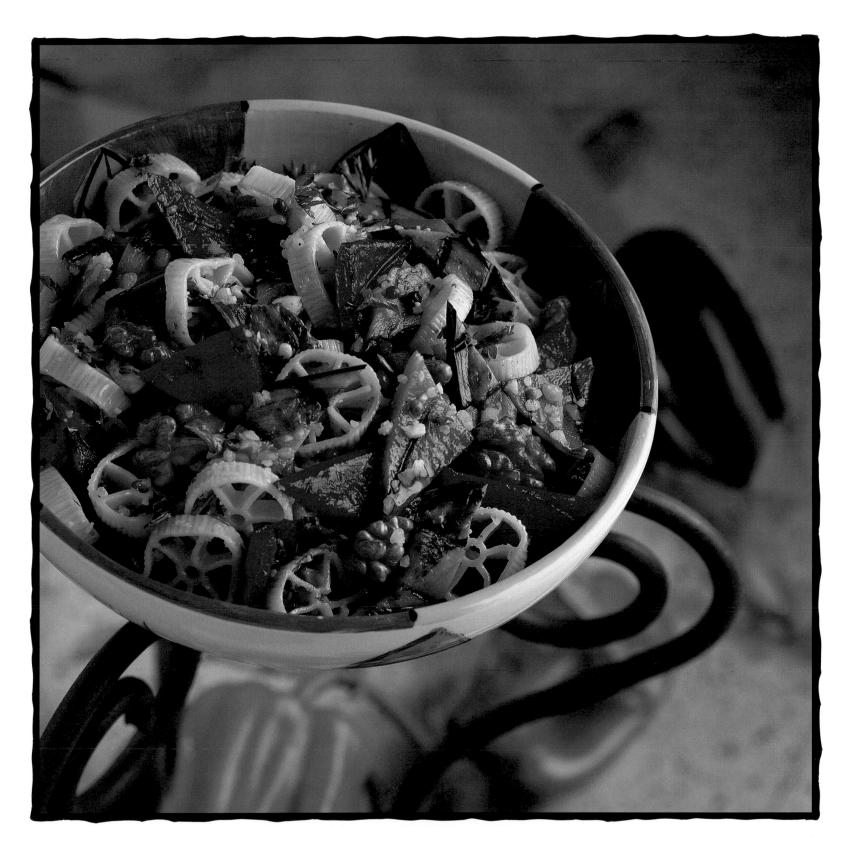

Pasta Starring Seafood

Whether you start with Thai green curry pasta with shrimp, Mediterranean pasta speckled with seared tuna, or crab ravioli crowned with a rich tomato sauce, seafood and pasta are a perfect match. The understated, slightly nutty flavor of pasta provides the perfect stage for seafood to play the starring role. Even using a small amount of seafood in a pasta dish will infuse the pasta with a unique taste. Nothing more than a salad and simple dessert are necessary to complete a perfect meal.

Key Pasta Techniques with Seafood

Buy only the freshest fish. Even the best frozen fish will cause the pasta to taste lifeless. For every 8 ounces of dried commercially made pasta, use 1 to 1½ pounds of seafood. This will serve 4 people as the main entrée. Exceptions to this rule include using ¾ pound of fresh lump crabmeat and 3 to 4 pounds of mussels or clams.

Follow the outline on page 54. Choose one of the eleven Master Pasta Recipes. Place a 12- to 14-inch sauté pan over high heat. Add the **seasonings,** and then add the seafood. Sauté until it just loses its raw outside color. (If cooking tuna, remove it as soon as it loses its raw outside color and then stir it into the pasta only during the last 30 seconds of cooking.) Add the **sauce,** bring to a simmer, and add the pasta. Toss until evenly combined and heated through. Then add the **finishing touches** and serve.

Raw shellfish: Shell and devein raw shrimp. (When fresh shrimp are unavailable, we prefer Thai black tiger prawns, which number 21 to 25 to a pound.) Cut large scallops in half. Clean squid. Pick through crabmeat and remove any shells. Note: We find that the precooked shrimp and lobster sold by fish markets are disappointing in pasta.

Firm-fleshed fish: Cut firm-fleshed, fresh raw fish, including swordfish, tuna, shark, salmon, and yellowtail, into bite-sized pieces.

Soft-fleshed fish: Soft-textured raw fish, including cod, halibut, snapper, and Mexican sea bass, which flake easily, should not be sautéed. Barbecue or broil this fish in advance, then cool and break the fish into bite-sized pieces. Refrigerate if cooked more than 30 minutes before adding it to the pasta. When the sauce comes to a simmer, add the fish and the pasta. Cook until evenly combined and heated through, then add the finishing touches.

Although this recipe uses both salmon and scallops, this dish is excellent when made with just one of these, or with another type of seafood such as crabmeat, shrimp, tuna, or swordfish. Because of the acidity of the lemon juice, be sure to use a nonreactive sauté pan, such as stainless steel, Calphalon, or a nonstick pan rather than a cast-iron pan, which will cause the sauce to acquire an unpleasant metallic taste.

Lemon Seafood Pasta

Serves 4 as the main entrée

INGREDIENTS

¾ pound raw fresh salmon fillet, skin and pin bones removed

¾ pound fresh bay scallops or shelled and deveined shrimp

1 pound fresh peas

½ pound button mushrooms

4 whole green onions

8 ounces dried orzo, fusilli, or your favorite pasta

½ cup parsley sprigs

2 ounces pecorino or Reggiano Parmesan cheese (optional)

SAUCE

¼ cup unsalted butter

2 cloves garlic, finely minced

1 tablespoon very finely minced ginger

½ cup chicken stock

2 teaspoons finely minced lemon zest

⅓ cup freshly squeezed lemon juice

⅓ cup sugar

¼ cup dry sherry

2 tablespoons thin soy sauce

2 teaspoons cornstarch

½ teaspoon Asian chile sauce

Salt to taste

ADVANCE PREPARATION

Cut salmon lengthwise into ½-inch-wide strips; cut the strips on a sharp diagonal into ¼-inch-wide pieces. Refrigerate with the scallops (or shrimp). Shell the peas. Quarter the mushrooms. Cut the green onions on a sharp diagonal into 1-inch lengths. Combine the vegetables and refrigerate. Set aside the pasta, parsley, and cheese in separate containers.

Combine the butter, garlic, and ginger; then refrigerate. In a bowl, combine the remaining sauce ingredients, and refrigerate. *All advance preparation steps may be completed up to 8 hours before you begin the final cooking steps.*

FINAL COOKING STEPS

Mince the parsley. Grate the cheese, about ½ cup. Bring 4 quarts of water to a rapid boil. Lightly salt the water, then cook the pasta according to the instructions on the package. When the pasta loses its raw texture but is still slightly firm, remove from the heat and drain.

Meanwhile, place a 12- or 14-inch sauté pan over high heat. Add half the butter-garlic mixture and sauté until the garlic begins to sizzle but has not browned. Add the seafood. Stir and toss until the salmon loses its raw outside color, then temporarily remove the seafood from the pan.

Return the sauté pan to high heat. Add the remaining butter-garlic mixture and sauté until the garlic begins to sizzle but has not browned. Add the vegetables. Stir and toss for 30 seconds, then add the sauce.

Bring the sauce to a rapid boil and cook until it thickens, about 30 seconds. Immediately return the seafood to the pan and add the pasta. Stir and toss until evenly combined and well heated. Taste and adjust the seasonings, especially for salt. Transfer the pasta to a heated platter or 4 heated dinner plates. Sprinkle on the parsley and cheese. Serve at once.

SUGGESTED ACCOMPANIMENTS

A watercress and walnut salad and a chocolate soufflé

Crisp panfried noodles topped with steamed clams or a stir-fry dish is one of the world's classic taste sensations. However, this technique does require cooking the pasta in advance and considerable last-minute attention to complete the final cooking steps. It's important to allow the precooked pasta to dry for several hours at room temperature. This step ensures that the exterior will become crisp when given a last-minute panfrying. Once this process is completed, the pasta is cut into wedges and kept warm in the oven while you cook the clams or the stir-fry dish.

Panfried Pasta with Clams

Serves 4 as the main entrée

INGREDIENTS

8 ounces dried spaghetti, linguine, or your favorite pasta

6 tablespoons flavorless cooking oil

40 steamer clams (about 2 pounds)

3 whole green onions

¼ cup loosely packed basil leaves

¼ cup loosely packed mint leaves

2 tablespoons very finely minced ginger

4 to 8 sprigs mint

SAUCE

⅔ cup chicken stock

3 tablespoons tomato sauce

2 tablespoons oyster sauce

2 tablespoons Chinese rice wine or dry sherry

1 tablespoon thin soy sauce

1 tablespoon dark sesame oil

1 tablespoon cornstarch

½ teaspoon sugar

¼ teaspoon freshly ground black pepper

ADVANCE PREPARATION

Bring 4 quarts of water to a rapid boil. Lightly salt the water, then cook the pasta according to the instructions on the package. When the pasta loses its raw texture but is still slightly firm, remove from heat, drain, rinse with cold water, and drain again. Spread 1 tablespoon of the cooking oil over the surface of a round 12-inch plate. Cover the plate evenly with the pasta. Leave uncovered at room temperature for 2 to 8 hours, turning the pasta over once.

Scrub the clams under cold water, then refrigerate. Mince the green onions, then refrigerate. Combine the basil and mint leaves and refrigerate. In a small container, combine 2 tablespoons of the cooking oil with the ginger, then set aside. In a small container, set aside the remaining 3 tablespoons cooking oil. Refrigerate the mint sprigs. In a small bowl, combine all the ingredients for the sauce. *All advance preparation steps may be completed up to 8 hours before you begin the final cooking steps.*

FINAL COOKING STEPS

Mince the basil and mint leaves. Preheat the oven to 200°. Place a 12- or 14-inch sauté pan over medium-high heat for 3 minutes. Add the remaining oil. When the oil gives off a wisp of smoke, transfer the pasta disk to the sauté pan.

Cook the pasta until golden on the underside, about 6 minutes. Then turn the pasta over and continue cooking until it turns golden on the other side, about 6 more minutes. Transfer the pasta to a cutting board, cut into wedges, and transfer the wedges to a heated platter or 4 heated dinner plates. Place the platter or plates in the warm oven.

Return the sauté pan to the stove and turn the heat to high. Add 1 cup water. When the water comes to a rapid boil, add the clams, cover the pan, and cook until the clams open, about 1 to 2 minutes. Immediately drain the clams in a colander. Discard any unopened clams. Return the sauté pan to high heat and add the oil-ginger mixture. Sauté until the ginger begins to sizzle, then add the sauce. Bring the sauce to a boil. Return the clams to the sauté pan, and add the basil and mint. Stir and toss so the clams are evenly coated with the sauce and are well heated. Spoon the clams and sauce across the pasta and garnish with the mint sprigs. Serve at once.

SUGGESTED ACCOMPANIMENTS

Roasted carrots, baby greens with a walnut oil dressing, and mango sorbet with chocolate candies

FRESH RICE NOODLES

Hot Pasta from Asia

BEAN THREAD NOODLES

RICE STICK NOODLES

CHINESE WHEAT NOODLES

CHINESE EGG NOODLES

Asians have elevated pasta making to an art. Nowhere else are noodles made from so many flours and starches, cooked by so many diverse techniques, and paired with such a startling range of seasonings, spices, and condiments. Following is a brief description of some of the most commonly available Asian pastas and ways to substitute them for all the dried wheat pastas in this book.

Bean thread noodles: Also called "glass noodles," "cellophane noodles," "Chinese vermicelli," and *sifun* by the Chinese, these are wiry, thin, transparent, dried noodles made from mung bean starch. Cover with the hottest tap water and soak for 30 minutes. Then drain and chop a few times to shorten their length. One ounce of dried bean threads will yield ¾ cup. Substitute the same amount of dried bean threads for dried wheat pastas in all the Asian recipes in this book. Bean threads and rice sticks are very low in carbohydrates, making them perfect for picnics, appetizers, and as a light first course.

Rice stick noodles: Called *mai fun* by the Chinese, these are made from rice starch. Although Asians usually deep-fry dry rice sticks and then use them as a crisp texture element in hot dishes and salads, rice sticks can be soaked in hot water and used exactly the same way as bean threads. Chinese rice sticks are threadlike. Thai rice sticks range from ⅟₁₆ to ½ inch wide. Substitute for the dried wheat pasta in all the Asian recipes in this book.

WONTON WRAPPERS

JAPANESE BUCKWHEAT SOBA NOODLES

JAPANESE SOMEN NOODLES

JAPANESE UDON NOODLES

Egg and wheat noodles: There are hundreds of varieties of Asian egg and wheat noodles. Unless you live near a large Asian community where fresh noodles are sold quickly, purchase dried noodles. Substitute the same quantity of dried egg or wheat noodles for all the dried wheat pastas in this book. If substituting fresh Asian noodles for dried pastas, for every 2 ounces of dried pasta use 3 ounces of fresh Asian noodles. During boiling, a large amount of foam will rise rapidly in the pot. Add a splash of cold water to the pot and the foam will subside.

Fresh rice noodles: These are pure white sheets of already cooked rice noodles made from a rice flour batter. After being steamed on shallow trays, they are lightly oiled and folded into rectangular packages. In large Asian markets, fresh rice noodles are sold unrefrigerated, often still warm from the initial steaming. At home, they will last a week refrigerated. To use, cut the noodles into ½-inch-wide strips. If the noodles have become brittle, run a little hot water over them until they soften. Separate the layers. Since these noodles are already cooked, boil them for a few seconds to reheat, or add them cold directly to the sauté pan that contains the pasta sauce. During the brief time it takes to glaze the rice noodles with the sauce, they will become piping hot. Substitute 2 ounces of fresh rice noodles for 1 ounce of dried wheat pasta in all the Asian recipes in this book.

GYOZA WRAPPERS

EGG ROLL WRAPPERS

Japanese udon noodles: Round or flat, flour–salt water, white wheat noodles, with a chewy texture, udon is common in Osaka and southern Japan. Substitute the same quantity of udon noodles for the dried wheat pastas in this book.

Japanese buckwheat soba noodles: Soba noodles, thin and brownish gray from the combination of buckwheat and white flour, are common in Tokyo and northern Japan. There are several kinds, including sobas flavored with tea, colored with egg, or made chewier with the addition of yam flour. Substitute the same quantity of soba noodles for the dried wheat pastas in this book.

Japanese somen noodles: Very fine, white noodles made from a hard-wheat dough moistened with cottonseed or sesame oil, these noodles are used just for soups and salads. Yellow somen noodles *(tomago somen)* are made with a dough enriched with egg yolks. Substitute the same quantity for all the dried wheat pastas used for pasta salads in this book.

Egg roll wrappers, wonton wrappers, and gyoza wrappers: Egg roll wrappers are thin sheets of egg noodle dough measuring 6 x 6 inches. Sold fresh by many markets, egg roll wrappers can be cut into noodles and cooked just the way you would cook fresh pasta. Wonton wrappers and gyoza wrappers are made from the same dough as egg roll wrappers. Their smaller size, about 3 inches square or 3 inches in diameter, respectively, make them ideal wrappers for Asian dumplings and Italian-style ravioli and tortellini.

For years we discarded the shrimp shells without realizing what a wonderful seafood flavor they can add to all shellfish sauces. When making a sauce for any seafood dish, just grind the raw shells along with the sauce ingredients in an electric blender. Then simmer the sauce for 20 minutes. Pour the sauce through a fine-meshed sieve to extract all the shells, and refrigerate the sauce until the final cooking steps.

Pasta with Gingered Seafood

Serves 4 as the main entrée

INGREDIENTS

¾ pound raw medium shrimp

¾ pound small sea scallops

12 small button mushrooms

5 stalks bok choy

4 whole green onions

2 tablespoons flavorless cooking oil

1 tablespoon cornstarch

8 ounces dried penne, bow ties, or your favorite pasta

¼ cup heavy cream

SAUCE

¼ cup chopped ginger

1 cup chicken stock

¼ cup Chinese rice wine or dry sherry

1 tablespoon thin soy sauce

1 tablespoon dark sesame oil

¼ teaspoon white pepper

¼ teaspoon salt

ADVANCE PREPARATION

Shell, devein, and split the shrimp lengthwise nearly in half. Save the shells. Combine the shrimp and scallops and refrigerate. Cut the mushrooms into ¼-inch-wide slices. Cut the bok choy stems and leaves and the green onions on a diagonal into ¼-inch-wide slices. In separate containers, set aside the cooking oil, cornstarch, pasta, and cream.

To make the sauce, place the shrimp shells and all sauce ingredients in an electric blender. Blend at high speed for 1 minute, then transfer to a small saucepan. Bring to a simmer, cover, and cook over low heat for 20 minutes. Return the sauce to the blender and blend at high speed for 1 minute. Now strain the mixture through a fine-meshed sieve or cheesecloth, then refrigerate (makes about ¾ cup). *All advance preparation steps may be completed up to 8 hours before you begin the final cooking steps.*

FINAL COOKING STEPS

Stir the cornstarch into the sauce. Bring 4 quarts of water to a rapid boil. Lightly salt the water, then cook the pasta according to the instructions on the package. When the pasta loses its raw texture but is still slightly firm, remove from the heat and drain.

Meanwhile, place a 12- or 14-inch sauté pan or 14- or 16-inch wok over high heat. When the pan becomes hot, add the cooking oil. When the oil gives off a wisp of smoke, add the shrimp and scallops. Stir and toss until the shrimp just lose their raw outside color, about 1 minute. Add the vegetables and stir and toss until they brighten, about 2 minutes.

Immediately add the pasta and sauce. Stir and toss until evenly combined and well heated. Taste and adjust the seasonings, especially for salt and pepper. Transfer the pasta to a heated platter or 4 heated dinner plates. Serve at once.

SUGGESTED ACCOMPANIMENTS

Baby lettuce greens and strawberry shortcake

The green curry paste used in this dish is a classic Thai preparation of spices, fresh serrano chiles, and basil ground into a paste either by hand or in the food processor. Although commercially made Thai green curry paste is sold by most Asian markets, the flavor of homemade is far superior. As with Italian pesto, plan to use Thai green curry paste within a few days or the beautiful green will blacken and the intense floral flavor of the basil will disappear.

Pasta with Green Curry Shrimp

Serves 4 as the main entrée

INGREDIENTS

1½ pounds raw medium shrimp

¾ cup unsweetened coconut milk

¼ cup Chinese rice wine or dry sherry

2 tablespoons Thai fish sauce

8 ounces dried fusilli, shells, or your favorite pasta

3 tablespoons flavorless cooking oil

GREEN CURRY PASTE

½ teaspoon salt

2 whole cloves

6 peppercorns

1 teaspoon coriander seeds

½ teaspoon caraway seeds

½ teaspoon cumin seeds

¼ cup flavorless cooking oil

5 cloves garlic

1 small shallot

5 whole serrano chiles, stemmed

¾ cup loosely packed basil leaves

ADVANCE PREPARATION

Shell, devein, and split the shrimp in half lengthwise, then refrigerate. In a small bowl, combine the coconut milk, rice wine, and fish sauce. Set aside the pasta and the 3 tablespoons cooking oil in separate containers.

To make the Green Curry Paste, in a small sauté pan, add the salt, cloves, peppercorns, coriander, caraway, and cumin. Toast over medium heat until the spices just begin to smoke. Transfer the spices to an electric spice or coffee grinder and grind into a powder. Then place the spices in an electric blender along with the ¼ cup cooking oil and all the remaining Green Curry Paste ingredients. Process until smooth. Transfer the Green Curry Paste to a small bowl, press plastic wrap across the surface, and refrigerate. *All advance preparation steps may be completed up to 8 hours before you begin the final cooking steps.*

FINAL COOKING STEPS

Bring 4 quarts of water to a rapid boil. Lightly salt the water, then cook the pasta according to the instructions on the package. When the pasta loses its raw texture but is still slightly firm, remove from the heat and drain.

Meanwhile, place a 12- or 14-inch sauté pan over high heat. When hot, add the 3 tablespoons cooking oil. When the oil gives off a wisp of smoke, add the shrimp. Stir and toss the shrimp until they lose their raw outside color, about 1 minute. Add the curry paste and mix evenly with the shrimp. Immediately add the coconut mixture and the pasta. Stir and toss until evenly combined and well heated. Taste and adjust the seasonings, especially for salt. Transfer the pasta to a heated platter or 4 heated dinner plates. Serve at once.

SUGGESTED ACCOMPANIMENTS

A tomato and watercress salad and roasted banana ice cream with fudge Sauce

In this recipe the marinade is brushed across the vegetables as they grill, as well as stirred into the pasta for added flavor. Although this marinade uses a combination of Mediterranean and Asian seasonings, any fruit juice–based marinade works well as a substitute provided the acidity from the fruit juice is balanced with sugar. When pasta is not on your menu plan, use this marinade for chicken before barbecuing or roasting.

Pasta with Swordfish and Grilled Vegetables

Serves 4 as the main entrée

INGREDIENTS

1½ pounds raw fresh swordfish

2 red bell peppers

1 bunch asparagus

3 ears white corn

5 whole green onions

3 ounces soft goat cheese

8 ounces dried linguine, spaghetti, or your favorite pasta

1 bunch chives

2 tablespoons olive oil

MARINADE

4 cloves garlic, finely minced

2 tablespoons very finely minced ginger

Zest of 2 limes, finely minced

Juice of 2 limes, about ¼ cup

½ cup chopped cilantro sprigs

¼ cup chopped basil leaves

½ cup extra virgin olive oil

½ cup Chinese rice wine or dry sherry

¼ cup oyster sauce

3 tablespoons light brown sugar

1 tablespoon Asian chile sauce

ADVANCE PREPARATION

Cut the swordfish into bite-sized pieces about 1 inch long and ¼ inch thick, then refrigerate. Trim the vegetables and leave whole for grilling. Crumble the goat cheese and refrigerate. Set aside the pasta. Chop the chives and set aside. Set aside the 2 tablespoons olive oil. In a bowl, combine all the marinade ingredients and stir well. Then add the vegetables and marinate for 30 minutes.

Grill the vegetables over medium heat on an indoor grill or on an outdoor gas or charcoal barbecue until they soften slightly. Then cut off the corn kernels, and cut the rest of the vegetables into bite-sized pieces. Combine the vegetables and refrigerate. Reserve the marinade and refrigerate. *All advance preparation steps may be completed up to 8 hours before you begin the final cooking steps.*

FINAL COOKING STEPS

Bring 4 quarts of water to a rapid boil. Lightly salt the water, then cook the pasta according to the instructions on the package. When the pasta loses its raw texture but is still slightly firm, remove from the heat and drain.

Meanwhile, place a 12- or 14-inch sauté pan over high heat. Add the 2 table-spoons olive oil. When the oil just begins to give off a wisp of smoke, add the swordfish. Stir and toss until the swordfish loses its raw outside color, about 1 minute. Immediately add the veg-etables. Stir and toss until the veg-etables are reheated, about 3 minutes.

Add the pasta and marinade. Stir and toss until evenly combined and well heated. Taste and adjust the season-ings. Transfer the pasta to a heated platter or 4 heated dinner plates. Sprinkle on the crumbled goat cheese and chopped chives. Serve at once.

SUGGESTED ACCOMPANIMENTS

A jicama and watercress salad and raspberry sorbet with chocolate mint cookies

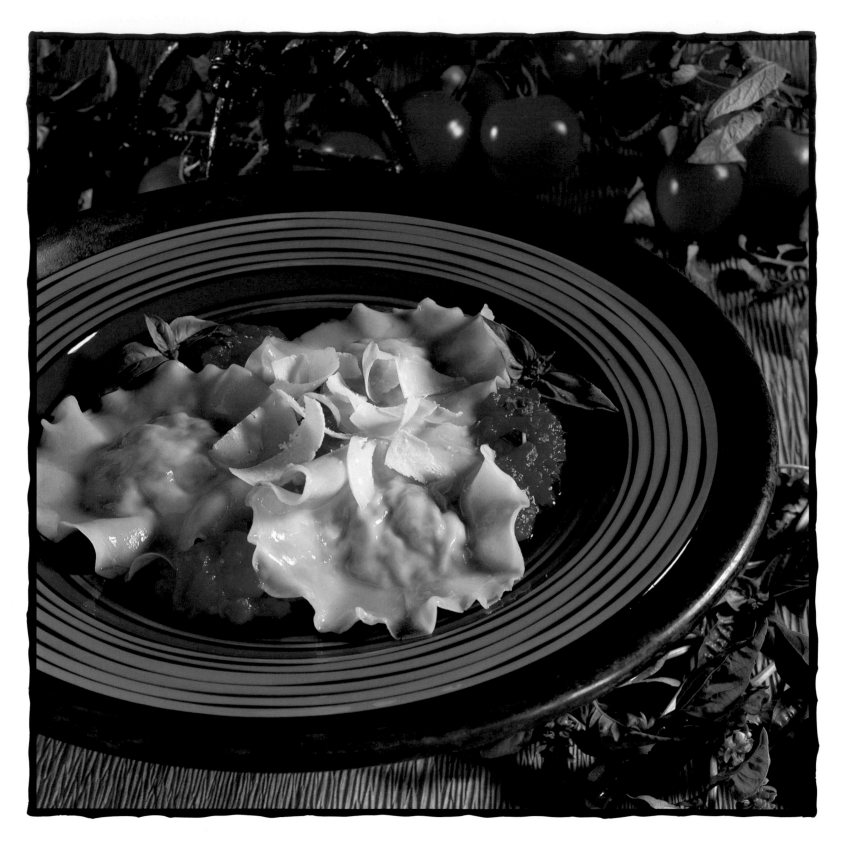

t is a terrible waste of money to buy frozen crabmeat. Its watery texture and briny taste are so totally dissimilar to the delectable sweetness and slightly firm resiliency of fresh crabmeat. If fresh crabmeat is not available, substitute an equivalent amount of raw shrimp or raw salmon fillet. Combined with the rest of the ingredients used in the ravioli filling, both variations will be a perfect match with the intense tomato sauce topping.

Crab Ravioli with Tomato

Serves 4 as the main entrée or 8 as an appetizer

INGREDIENTS

4 cups washed and loosely packed
 spinach leaves

½ pound fresh lump crabmeat or raw
 shrimp, minced

½ pound ricotta cheese

2 whole green onions, minced

1 tablespoon very finely minced
 ginger

½ teaspoon salt

60 round gyoza or thin wonton
 wrappers

2 eggs, beaten

¼ cup cornstarch

½ cup loosely packed green or opal
 basil leaves

2 ounces pecorino or Reggiano
 Parmesan cheese

8 sprigs basil

SAUCE

4 cloves garlic, finely minced

3 tablespoons extra virgin olive oil

3 cups seeded and minced vine-
 ripened tomatoes

1 cup chicken stock

1 teaspoon tomato paste

½ teaspoon Asian chile sauce

½ teaspoon sugar

½ teaspoon salt

ADVANCE PREPARATION

In a 2-quart saucepan, bring 2 cups of water to a boil. Blanch spinach in the boiling water, and when wilted, rinse with cold water. Press the spinach into a small ball, then mince. Pick through the crab and remove any shells or cartilage. In a small bowl, combine the spinach, crab, ricotta, green onions, ginger, and salt, and mix thoroughly.

Place 2 teaspoons of the filling in the center of a wrapper. (If using square wonton wrappers, trim them into circles.) Moisten the edge with a little beaten egg. Place another wrapper on top and firmly press the wrappers together to tightly seal. Repeat with remaining ravioli. Line a baking sheet with parchment paper, dust the paper heavily with cornstarch, place the ravioli in a single layer on the baking sheet, and refrigerate uncovered.

In separate containers, refrigerate the basil leaves, cheese, and basil sprigs. To make the sauce, combine the garlic and olive oil in a bowl. In another bowl, combine all the remaining sauce ingredients. *All advance preparation steps may be completed up to 8 hours before you begin the final cooking steps.*

FINAL COOKING STEPS

Chop the basil. Shave the cheese, about ½ cup. Place a 12- or 14-inch sauté pan over high heat. Add the garlic-oil mixture. Sauté until the garlic begins to sizzle but has not browned. Add the tomato sauce and bring to a rapid boil. Cook until the sauce begins to thicken, about 8 minutes. Stir in the basil. Taste and adjust the seasonings, especially for salt. Reduce the heat to a very low setting and keep the sauce warm.

Over high heat, bring 4 quarts of water to a rapid boil. Lightly salt the water, then stir in the ravioli. As soon as the ravioli rise to the surface, about 45 seconds, gently transfer them to a colander to drain briefly. Transfer the ravioli to a heated platter or 4 heated dinner plates. Spoon the sauce over the ravioli and sprinkle on the cheese. Alternatively, place the sauce on the plates and top with the ravioli and cheese. Serve at once.

SUGGESTED ACCOMPANIMENTS

Baby greens with grilled vegetables and chocolate brownies with strawberries

The secret for this recipe is to use very fresh, bright red tuna and to cook the tuna quickly. The tuna is given a preliminary searing and then seconds later incorporated into the pasta dish for a few seconds of additional cooking. Only by very briefly cooking the tuna will it be bright red in the interior and very tender. Easy variations for this recipe include replacing the tuna with swordfish, crabmeat, or shrimp, or leaving out the tuna and serving this as a vegetarian pasta dish to accompany barbecued meat or seafood.

Mediterranean Pasta with Seared Tuna

Serves 4 as the main entrée

INGREDIENTS

1½ pounds fresh tuna

16 button mushrooms

2 cups sugar snap peas

4 whole green onions

½ cup pine nuts

⅔ cup loosely packed basil leaves

⅔ cup loosely packed parsley sprigs

4 ounces goat cheese

4 ounces Asiago or Reggiano Parmesan cheese

8 ounces dried green fettucine, linguine, or your favorite pasta

SAUCE

⅓ cup extra virgin olive oil

5 cloves garlic, finely minced

1 cup chicken stock

2 teaspoons finely minced lemon zest

2 teaspoons cornstarch

1 teaspoon salt

½ teaspoon crushed red pepper flakes

ADVANCE PREPARATION

Preheat the oven to 325° (for toasting the pine nuts). Cut the tuna into ¼-inch-wide slices and cut the slices into 1-inch lengths; then refrigerate. Cut the mushrooms into ⅛-inch-wide slices. Stem the sugar snap peas. Cut the green onions on a sharp diagonal into 1-inch lengths. Combine the vegetables and refrigerate. Toast the pine nuts in the preheated oven until golden, about 8 minutes, and set aside. Combine basil and parsley and set aside. Crumble the goat cheese and refrigerate.

In a small container, combine the oil and garlic. In a small bowl, combine all the remaining sauce ingredients, and refrigerate. *All advance preparation steps may be completed up to 8 hours before you begin the final cooking steps.*

FINAL COOKING STEPS

Chop the basil and parsley. Grate the Asiago, about 1 cup. Bring 4 quarts of water to a rapid boil. Lightly salt the water, then cook the pasta according to the instructions on the package. When the pasta loses its raw texture but is still slightly firm, remove from the heat and drain.

Meanwhile, place a 12- or 14-inch sauté pan over high heat. When hot, add half the oil-garlic mixture. Sauté until the garlic begins to sizzle but has not browned. Add the tuna. Stir and toss until the tuna just loses its raw outside color, about 1 minute, then temporarily remove the fish from the pan.

Return the sauté pan to high heat. Add the remaining oil-garlic mixture. Sauté until the garlic begins to sizzle but has not browned. Add the vegetables. Stir and toss until the peas brighten, about 1 minute. Add the pasta, three-fourths of the chopped herbs, the pine nuts, sauce, and the cheeses. Stir and toss until evenly combined and well heated. Add the tuna and combine evenly. Taste and adjust the seasonings, especially for salt. Transfer the pasta to a heated platter or 4 heated dinner plates. Sprinkle on the remaining herbs. Serve at once.

SUGGESTED ACCOMPANIMENTS

A Thai-style papaya and cucumber salad and a praline swirl cheesecake

In this recipe the long, finishing taste of hoisin sauce sets the stage for the other flavors of chopped fresh herbs, ginger, garlic, chiles, and orange zest. If you leave out the hoisin, substitute another low-note, intensely flavored ingredient such as an equivalent amount of oyster sauce, 1 tablespoon tomato paste, or 4 ounces of grated pecorino or Reggiano Parmesan, or replace the chicken stock with cream or coconut milk.

Sea Bass with Herb-Speckled Pasta

Serves 4 as the main entrée

INGREDIENTS

1½ pounds fresh Chilean sea bass or raw shrimp

2 red bell peppers

8 ounces dried cartwheels, bow ties, or your favorite pasta

½ cup loosely packed basil leaves

½ cup loosely packed mint leaves

½ cup loosely packed cilantro sprigs

SAUCE

¼ cup extra virgin olive oil

5 cloves garlic, finely minced

1 tablespoon very finely minced ginger

1 cup chicken stock

2 tablespoons hoisin sauce

2 teaspoons cornstarch

1 teaspoon Asian chile sauce

1 teaspoon salt

1 teaspoon finely minced orange zest

ADVANCE PREPARATION

Cut the sea bass into bite-sized pieces about 1 inch long and ¼ inch thick (or shell, devein, and split the shrimp lengthwise nearly in half); then refrigerate. Seed, stem, and shred the peppers, and refrigerate. Set aside the pasta. Combine the herbs and refrigerate.

In a small bowl, combine the oil, garlic, and ginger. In another bowl, combine all the remaining sauce ingredients, and refrigerate. *All advance preparation steps may be completed up to 8 hours before you begin the final cooking steps.*

FINAL COOKING STEPS

Chop the herbs. Bring 4 quarts of water to a rapid boil. Lightly salt the water, then cook the pasta according to the instructions on the package. When the pasta loses its raw texture but is still slightly firm, remove from the heat and drain.

Meanwhile, place a 12- or 14-inch sauté pan over high heat. Add the garlic-oil mixture and sauté until the garlic begins to sizzle but has not browned. Add the sea bass (or shrimp). Sauté until the sea bass or shrimp turn white. Add the red pepper, pasta, herbs, and sauce.

Stir and toss until evenly combined and well heated. Taste and adjust the seasonings, especially for salt. Transfer the pasta to a heated platter or 4 heated dinner plates. Serve at once.

SUGGESTED ACCOMPANIMENTS

A tomato-jicama salad with toasted pine nuts and a strawberry-chocolate cake

Caribbean cooking fuses rich cooking traditions from around the world. This recipe uses one of our favorite sauces, in which the flavors of tomato, curry, allspice, chiles, and ginger play starring roles. For variety, substitute unsweetened coconut milk for the chicken stock, replace the cilantro with a blend of chopped mint and basil, or omit the chile sauce and add finely minced fresh serrano or Scotch bonnet chiles.

Caribbean Pasta with Shrimp

Serves 4 as the main entrée

INGREDIENTS

1½ pounds raw medium shrimp

4 cloves garlic, finely minced

¼ cup minced shallots

1 tablespoon finely minced ginger

3 tablespoons flavorless cooking oil

8 ounces dried radiatore, fusilli, or
 your favorite pasta

½ cup cilantro sprigs

SAUCE

1 green bell pepper, seeded and
 chopped

1½ cups seeded and chopped vine-
 ripened tomatoes

2 teaspoons curry powder

½ teaspoon allspice berries, finely
 crushed

½ cup chicken stock

¼ cup Grand Marnier

2 tablespoons thin soy sauce

1 tablespoon light brown sugar

2 teaspoons cornstarch

1 teaspoon Caribbean or Asian chile
 sauce

ADVANCE PREPARATION

Shell, devein, and split the shrimp lengthwise nearly in half; then refrigerate. In a small bowl, combine the garlic, shallots, ginger, and oil. In separate containers, set aside the pasta and cilantro. In a small bowl, combine all the ingredients for the sauce, then refrigerate. *All advance preparation steps may be completed up to 8 hours before you begin the final cooking steps.*

FINAL COOKING STEPS

Chop the cilantro. Bring 4 quarts of water to a rapid boil. Lightly salt the water, then cook the pasta according to the instructions on the package. When the pasta loses its raw texture but is still slightly firm, remove from the heat and drain.

Meanwhile, place a 12- or 14-inch sauté pan over high heat. When hot, add the garlic-oil mixture. Sauté until the garlic begins to sizzle but has not browned. Stir the sauce, then pour into the sauté pan. Bring the sauce to a rapid boil, and cook until it begins to thicken, about 3 minutes.

Stir in the shrimp. Stir and toss the shrimp until they turn white and have just lost their raw interior color (cut into one to check), about 2 minutes. Immediately add the pasta. Stir and toss until evenly combined and well heated. Taste and adjust the seasonings, especially for salt. Transfer the pasta to a heated platter or 4 heated dinner plates. Sprinkle on the cilantro and serve at once.

SUGGESTED ACCOMPANIMENTS

A watermelon and red onion salad and a pineapple upside-down rum cake

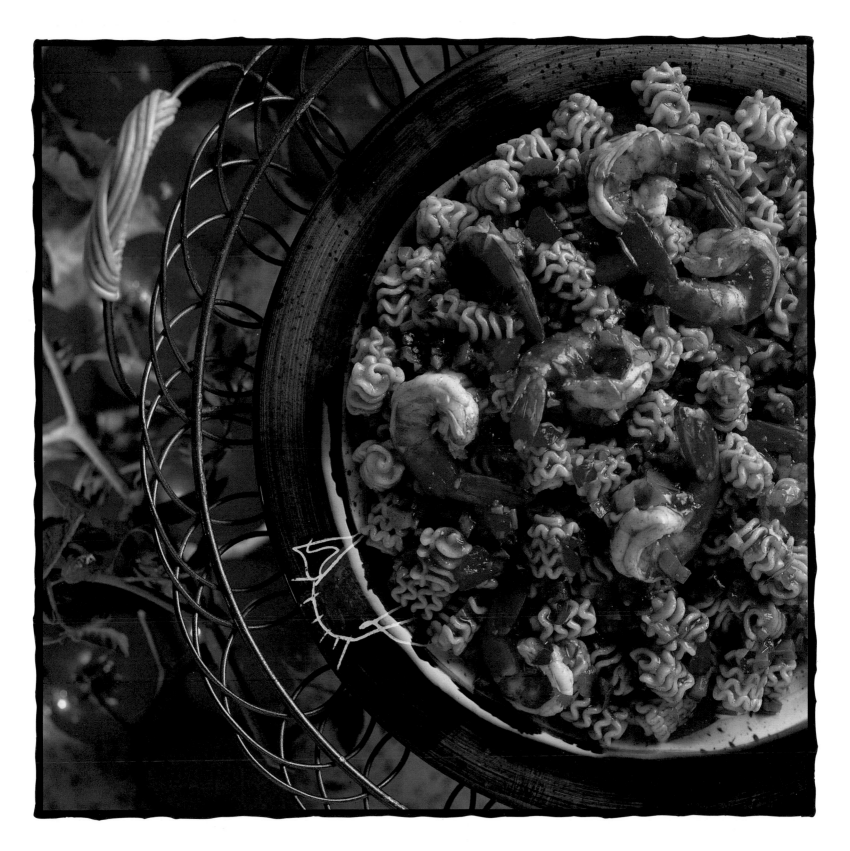

Quick Hot Pasta Recipes

Here are glorious pasta recipes to savor night after night! Choose from a wondrous range of dried pastas. Select a few readily available seasonings, spices, fresh herbs, and condiments. Finish the dish with grated Parmesan or crumbled goat cheese, or sprinkle with toasted pine nuts that were tucked away in the freezer. Quickly made and utterly delectable, the following simple combinations make great pasta dishes for one or a crowd and are soul-satisfying meals after a hard workday or when you want to entertain with minimal preparation and cooking.

Simple Preparation and Cooking Steps

Choose one of the following pasta recipes. Have ready 2 ounces dried or 3 ounces fresh pasta per person. For every 8 ounces of dried pasta, bring 4 quarts of water to a rapid boil. Have ready the seasonings, sauce, and finishing touches. These quantities are based on 8 ounces of dried pasta.

If you want to add vegetables, review pages 12–31. If you want to add seafood or meat, review pages 36–41 and 60–81. If you want to create a rich dish by using cream or dairy products, review pages 82–105.

1. Lightly salt the water, then cook the pasta according to the instructions on the package. When the pasta loses its raw texture but is still slightly firm, remove from the heat and drain.

2. Return the empty pasta pot to the stove over medium heat. Add the **seasonings**. Sauté for a few seconds.

3. Add the **sauce** and bring to a low boil.

4. Return the pasta to the pot and combine until evenly mixed.

5. Add the **finishing touches.** Taste the dish. If the dish tastes flat, add more salt. Serve at once. Celebrate!

Master Pasta Recipes

Thai Coconut Pasta

Seasonings: Combine 3 tablespoons flavorless cooking oil, 2 tablespoons finely minced ginger, and 2 cloves minced garlic.

Sauce: Combine ¾ cup coconut milk, ¼ cup dry sherry, 2 tablespoons oyster sauce, 2 teaspoons cornstarch, 1 teaspoon Asian chile sauce, and ½ cup total chopped cilantro and basil.

Finishing touches: Squeeze on the juice from 1 lime and ½ cup mixed cilantro and basil.

Pasta Chinese

Seasonings: Combine 3 tablespoons flavorless cooking oil, 1 tablespoon finely minced ginger, and 4 cloves minced garlic.

Sauce: Combine ¼ cup orange juice, 3 tablespoons thin soy sauce, 2 tablespoons rice vinegar, 2 tablespoons brown sugar, 1 tablespoon dark sesame oil, 2 teaspoons cornstarch, 1 teaspoon Asian chile sauce, ½ teaspoon minced orange zest, and ¾ cup chopped cilantro.

Finishing touches: Sprinkle on 2 tablespoons toasted sesame seeds.

Pasta Italian

Seasonings: Combine ¼ cup extra virgin olive oil and 3 cloves minced garlic.

Sauce: Combine ⅓ cup pasta water or chicken stock, 1 cup chopped parsley, 2 teaspoons cornstarch, 1 teaspoon minced lemon zest, ½ teaspoon salt, ½ teaspoon freshly ground black pepper or crushed red pepper flakes.

Finishing touches: Sprinkle on ½ cup toasted pine nuts or walnuts, and ½ cup freshly grated Parmesan.

Pasta Pesto

Seasonings: ½ cup homemade or store-bought pesto.

Sauce: Combine ½ cup pasta water or chicken stock, and salt and pepper to taste.

Finishing touches: Sprinkle on ½ cup freshly grated Parmesan.

Southwest Pasta

Seasonings: Combine ¼ cup extra virgin olive oil and 4 cloves minced garlic.

Sauce: Combine 1 cup chopped tomatoes or tomato purée, ½ cup white wine, ¼ cup lime juice, 1 tablespoon puréed canned chipotle chiles, 2 tablespoons brown sugar, 2 teaspoons cornstarch, 1 teaspoon ground cumin, ½ teaspoon salt, ⅓ cup chopped cilantro.

Finishing touches: Sprinkle on 3 ounces of crumbled goat cheese.

Curried Pasta

Seasonings: Combine 3 tablespoons flavorless cooking oil, 2 tablespoons curry powder, 3 cloves minced garlic, and 1 tablespoon finely minced ginger.

Sauce: Combine 1 cup coconut milk, ½ cup chicken stock, 2 tablespoons oyster sauce, 1 tablespoon dark sesame oil, 2 teaspoons cornstarch, 1 teaspoon Asian chile sauce, and ½ cup chopped basil.

Finishing touches: Sprinkle on ½ cup chopped mint or cilantro.

Pasta Caribbean

Seasonings: Combine ¼ cup flavorless cooking oil, 4 cloves minced garlic, and 2 tablespoons finely minced ginger.

Sauce: Combine 1 cup chopped tomato, ½ cup chicken stock, ¼ cup Grand Marnier, 2 tablespoons thin soy sauce, 1 tablespoon brown sugar, 2 teaspoons curry powder, 2 teaspoons cornstarch, 1 teaspoon Caribbean or Asian chile sauce, and ½ teaspoon salt.

Finishing touches: Sprinkle on ⅓ cup chopped cilantro or basil.

Spicy Tomato Pasta

Seasonings: Combine ¼ cup extra virgin olive oil and 4 cloves minced garlic.

Sauce: Combine 4 cups seeded and chopped vine-ripened tomatoes, 2 teaspoons minced lemon zest, 2 teaspoons cornstarch, 1 teaspoon crushed red pepper flakes, 1 teaspoon salt, and 1 cup chopped parsley or mint.

Finishing touches: Sprinkle on 2 ounces freshly grated Parmesan.

Herb Pasta

Seasonings: Combine ¼ cup extra virgin olive oil with 3 cloves minced garlic.

Sauce: Combine 1 cup chicken stock, 1 tablespoon cornstarch, 1 teaspoon minced lemon zest, ½ teaspoon salt, and ½ teaspoon freshly ground black pepper.

Finishing touches: Stir into the pasta 1 cup freshly grated Parmesan and ½ cup toasted pine nuts, ½ cup chopped basil, ¼ cup chopped mint, and ¼ cup chopped cilantro.

Moroccan Pasta

Seasonings: Combine ¼ cup extra virgin olive oil, 4 cloves minced garlic, and 2 tablespoons finely minced ginger.

Sauce: Combine ⅓ cup chopped cilantro, ⅓ cup chopped mint, ⅓ cup chicken stock, ¼ cup lemon juice, 3 tablespoons honey, 2 teaspoons ground cumin, 2 teaspoons sweet paprika, 2 teaspoons cornstarch, ½ teaspoon crushed red pepper, and ½ teaspoon salt.

Finishing touches: Stir into the pasta ½ cup toasted pine nuts, ½ cup pitted and chopped olives. Before serving, grate a little nutmeg over each portion.

Gorgonzola Pasta

Seasonings: Combine ¼ cup extra virgin olive oil and 3 cloves minced garlic.

Sauce: Combine 4 ounces crumbled Gorgonzola, ½ cup chicken stock or cream, ½ cup chopped basil leaves, ½ teaspoon salt, and ¼ teaspoon crushed red pepper flakes.

Finishing touches: Sprinkle on ½ cup toasted and chopped walnuts.

*P*art of the fun of cooking is seeing the possibilities for endless recipe variations. This fantastic-tasting dish can be modified in so many ways. Replace the tomato sauce with chopped vine-ripened tomatoes, or omit it entirely. Leave out the curry powder or substitute a smaller amount of Indian curry paste. Chopped fresh basil or mint, or a combination of the two, would be great instead of the cilantro. And if you don't want to use coconut milk, replace it with an equal amount of chicken broth, plus 1 tablespoon of cornstarch so that the sauce thickens into a nice glaze during cooking.

Coconut Herb Pasta with Shellfish

Serves 4 as the main entrée

INGREDIENTS

20 steamer clams (about 1 pound)

1 pound raw medium shrimp or bay scallops

12 button mushrooms

1 bunch pencil-thin asparagus

8 ounces dried shells, radiatore, or your favorite pasta

SAUCE

3 tablespoons flavorless cooking oil

4 cloves garlic, finely minced

1 tablespoon very finely minced ginger

½ cup unsweetened coconut milk

¼ cup chicken stock

3 tablespoons tomato sauce

2 tablespoons Chinese rice wine or dry sherry

1 tablespoon curry powder

1 tablespoon thin soy sauce

1 tablespoon oyster sauce

1 tablespoon dark sesame oil

½ teaspoon sugar

¼ cup minced cilantro sprigs or basil leaves

ADVANCE PREPARATION

Scrub the clams under cold water, then refrigerate. Shell, devein, and deeply split the shrimp lengthwise, then refrigerate. Cut the mushrooms into ⅛-inch-wide slices. Snap off and discard the tough asparagus ends, then cut asparagus on a sharp diagonal into 1-inch lengths. Combine the mushrooms and asparagus and refrigerate. Set aside the pasta.

To make the sauce, in a small bowl, combine the oil, garlic, and ginger. In another bowl, combine all the remaining sauce ingredients, and refrigerate. *All advance preparation steps may be completed up to 8 hours before you begin the final cooking steps.*

FINAL COOKING STEPS

Bring 4 quarts of water to a rapid boil. Lightly salt the water, then cook the pasta according to the instructions on the package. When the pasta loses its raw texture but is still slightly firm, remove from the heat and drain.

Meanwhile, place a 12- or 14-inch sauté pan over high heat. Add 1 cup of water and bring to a rapid boil. Add the clams, cover the pan, and cook until they open, about 1 to 2 minutes. Immediately drain the clams in a colander. Discard any unopened clams.

Return the sauté pan to the stove over high heat. Add the oil-garlic mixture and sauté until the garlic begins to sizzle, but has not browned. Add the shrimp. Stir and toss the shrimp until they just lose their raw outside color, about 1 minute. Add the vegetables. Stir and toss until the asparagus brightens, about 2 minutes.

Immediately add the clams, sauce, and pasta. Stir and toss until evenly combined and well heated. Taste and adjust the seasonings, especially for salt. Transfer the pasta to a heated platter or 4 heated dinner plates. Serve at once.

SUGGESTED ACCOMPANIMENTS

A Caesar salad with cheese-coated croutons and an apricot mousse

The key flavor technique in this recipe is to sauté a large amount of finely minced ginger in butter until the ginger sizzles and the butter turns a light brown. The ginger infuses the butter with its peppery high notes, while the browned butter contributes a rich nutty quality. For variations, substitute large sea scallops that are thinly sliced for the salmon, fresh peas for the asparagus, or for a decadent twist, replace the chicken stock with whipping cream.

Ginger Butter Pasta with Salmon

Serves 4 as the main entrée

INGREDIENTS

1½ pounds raw fresh salmon fillet, skin and pin bones removed

1 bunch thin asparagus

½ cup pine nuts

½ cup loosely packed basil leaves

½ cup loosely packed cilantro sprigs

8 ounces dried fettucine, spaghetti, or your favorite pasta

2 ounces pecorino or Reggiano Parmesan cheese

1 tablespoon lemon zest threads, for garnish

SAUCE

¼ cup unsalted butter

3 tablespoons very finely minced ginger

1 tablespoon minced lemon zest

½ cup chicken stock

2 tablespoons oyster sauce

1 tablespoon light brown sugar

½ teaspoon Asian chile sauce

1 teaspoon cornstarch

ADVANCE PREPARATION

Preheat the oven to 325° for toasting the pine nuts. Cut the salmon lengthwise into ¼-inch-thick slices. Then cut the slices into ½ x 1-inch rectangles, and refrigerate. Snap off and discard the tough asparagus stems. Cut the asparagus on a sharp diagonal into 1-inch lengths, then refrigerate. Toast the nuts in the preheated oven until golden, about 8 minutes; then set aside. Combine the basil and cilantro. Separately set aside the pasta, cheese, and lemon zest.

In a small container, combine the butter and ginger. In a small bowl, combine the remaining sauce ingredients, and refrigerate. *All advance preparation steps may be completed up to 8 hours before you begin the final cooking steps.*

FINAL COOKING STEPS

Chop the herbs and set aside. Grate the cheese, about ½ cup. Bring 4 quarts of water to a rapid boil. Lightly salt the water, then cook the pasta according to the instructions on the package. When the pasta loses its raw texture but is still slightly firm, remove from the heat and drain.

Meanwhile, place a 12- or 14-inch sauté pan over high heat. Add the butter and ginger. Sauté the butter and ginger until the butter browns slightly, about 2 minutes. Add the salmon and asparagus. Sauté until the salmon loses its raw outside color and the asparagus brightens, about 2 minutes.

Add the pasta, herbs, pine nuts, and sauce. Stir and toss until evenly combined and well heated. Taste and adjust the seasonings, especially for salt. Transfer the pasta to a heated platter or 4 heated dinner plates. Sprinkle on the cheese and lemon zest. Serve at once.

SUGGESTED ACCOMPANIMENTS

A tomato-cucumber salad and hot cherry cobbler

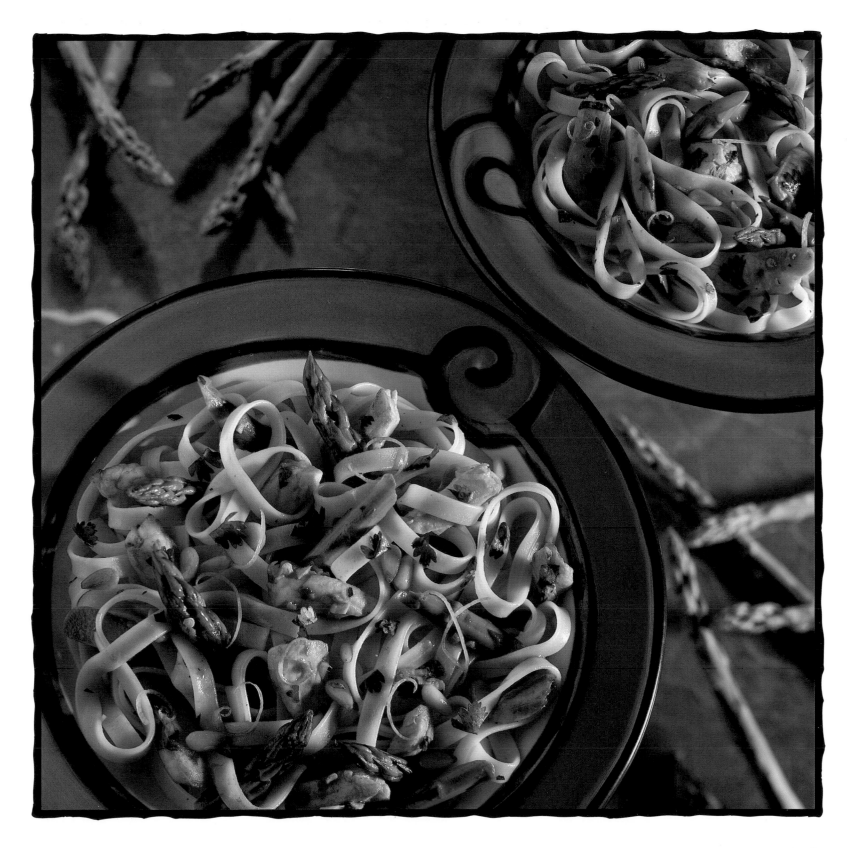

Boldly Flavored Meat Pastas

The subtle flavors of seafood and delicate sauces create divine combinations when paired with pasta, but meat and pasta only work when tied together with assertive herbs, robust sauces, and flavor-intense spices. Except for salt, sugar, or huge doses of chiles, adding more seasonings almost always improves the taste of pasta when matched with beef, lamb, veal, and poultry. In this chapter, pastas are the foundation for a rich red wine–lamb shank sauce, for a spicy Moroccan mix of lemon, chiles, and herbs, and for a wonderful Southwest-inspired smoked chicken and goat cheese dish. Take these recipes as a starting point for creating your own robust meat pasta dishes and cook boldly.

Key Pasta Techniques with Meats

For every 8 ounces of dried commercially made pasta, use 1 to 1½ pounds of meat. This will serve 4 people. Follow the outline for creating your own pasta recipes on page 54. Choose one of the eleven Master Pasta Recipes. Add the **seasonings** and then sauté the raw meat until the outside raw color disappears. Add the **sauce,** and bring to a simmer. If using cuts of meat that will be tender with brief cooking, then the moment the meat is cooked in the center, add the pasta. If using tougher cuts of meat, simmer until the meat becomes tender, then add the pasta. Toss until evenly combined and heated through. Add the **finishing touches** and serve.

Quick-cooking meats: Skinned chicken breasts and thigh meat, duck meat, rabbit meat, beef tenderloin and rib-eye steak, pork loin and tenderloin, lamb leg meat, and veal scallopini. Cut the meat into bite-sized pieces.

Long-cooking meats: Beef chuck, lamb shoulder and shank meat, meat from country-style spareribs and pork butt, meat from veal shanks. Cut the meat into bite-sized pieces.

Cooked meats: Pasta recipes are a wonderful way to finish leftover meat from a previous meal. Cut the meat into bite-sized pieces. Add a few tablespoons of cooking oil to a 12- or 14-inch sauté pan. Add the meat with its remaining sauce or gravy. If there is not at least 1 cup of sauce or gravy, then add a **sauce.** Bring to a simmer and add the pasta. When evenly combined and heated through, add the **finishing touches** and serve.

When Americans choose meat to stew, the choices are usually beef chuck, lamb shanks, lamb shoulder, and veal shanks. Yet if you follow the Asian tradition and substitute pork for whatever beef, lamb, or veal stew you plan to make, the results are even better. Because pork is finer grained and better marbled than lamb or veal, after long cooking the meat acquires a succulent sweetness lacking in all other meats. It's important not to use very lean cuts of pork. Use the meat from country-style spareribs and pork butt. The following pork stew makes a great topping for pasta.

Pasta with Thai Coconut Pork

Serves 4 as the main entrée

INGREDIENTS

¼ cup flavorless cooking oil

5 cloves garlic, finely minced

2 tablespoons very finely minced ginger

1 pound meat from country-style spareribs or pork butt

1 bunch baby carrots, stemmed and peeled

2 cups shelled peas or frozen petit peas

½ cup cilantro sprigs

2 teaspoons cornstarch

8 ounces dried mafaldine, fusilli, or your favorite pasta

SAUCE

1 cup unsweetened coconut milk

½ cup chicken stock

¼ cup Chinese rice wine or dry sherry

2 tablespoons Thai fish sauce, or ½ teaspoon salt

1 teaspoon minced lime zest

1 teaspoon Asian chile sauce

ADVANCE PREPARATION

In a small container, combine the oil, garlic, and ginger. Cut the pork into ½-inch-wide pieces. Set aside the carrots. Shell the peas. Set aside the cilantro, cornstarch, and pasta. In a bowl, combine all sauce ingredients.

Place a 12- or 14-inch sauté pan over high heat. When hot, add the oil-garlic mixture and sauté until the garlic begins to sizzle but has not browned. Add the pork. Stir and toss the pork until it loses its raw color on the outside, about 4 minutes. Pour in the sauce. Bring to a low boil, and reduce the heat to low. Stir in the carrots, cover, and simmer until the pork is tender, about 30 minutes. If the sauce is made more than 1 hour in advance of serving, cool, transfer to a bowl, and refrigerate. *All advance preparation steps may be completed up to 1 day before you begin the final cooking steps.*

FINAL COOKING STEPS

Chop the cilantro. Combine the cornstarch and 2 teaspoons cold water. Bring 4 quarts of water to a rapid boil. Lightly salt the water, then cook the pasta according to the instructions on the package. When the pasta loses its raw texture but is still slightly firm, remove from the heat and drain.

Meanwhile, bring the pork to a simmer. Add the peas, and simmer until the peas brighten, about 5 minutes. Taste and adjust the seasonings, especially for salt. If the sauce appears watery, stir in the cornstarch mixture. Transfer the pasta to a heated platter or 4 heated dinner plates. Spoon the pork over the pasta, sprinkle on the cilantro, and serve at once.

SUGGESTED ACCOMPANIMENTS

Thai-style papaya salad and a flourless almond cake with a Kahlua sauce

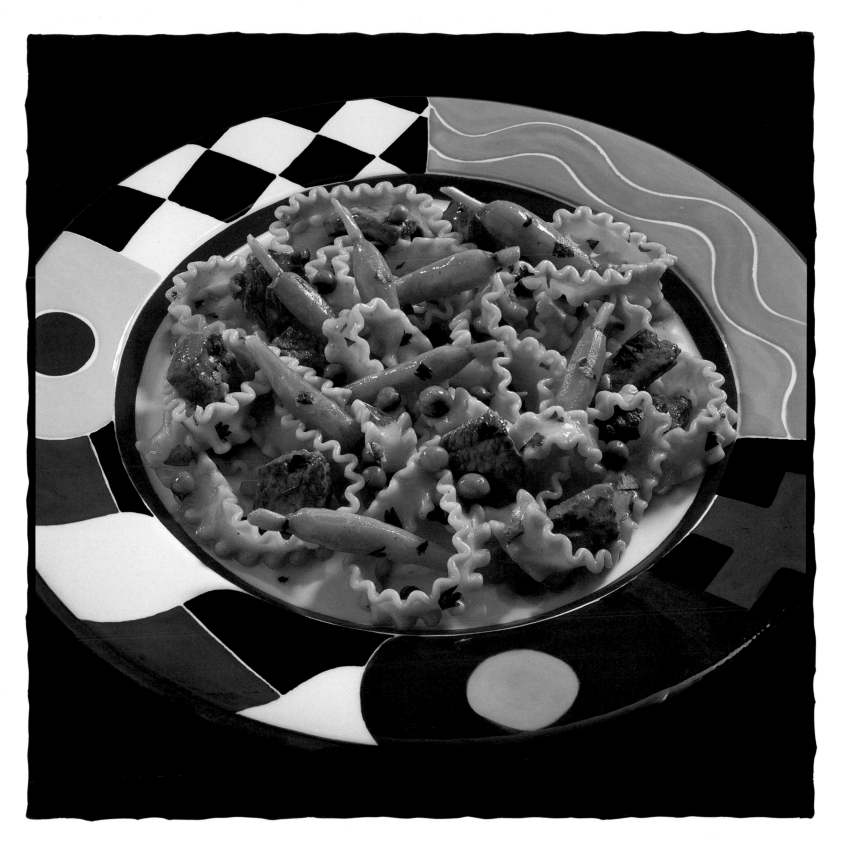

This Thai version of the northern Chinese classic has many variations. In place of the ground veal, try substituting ground chicken, pork, lamb, or raw minced shrimp or salmon. Vary the flavor of the sauce. Substitute freshly squeezed orange or tangerine juice for the coconut milk. Omit the curry powder. Use a blend of chopped mint, basil, cilantro, and chives. Or add 1 teaspoon of finely minced lime zest. Any of these variations will make you a culinary hero.

Thai Veal Potstickers

Serves 6 to 10 as an appetizer or 4 as the main entrée

INGREDIENTS

2 small whole green onions, minced

1 tablespoon very finely minced ginger

1 pound ground veal, pork, or chicken

2 tablespoons oyster sauce

1 tablespoon Chinese rice wine or dry sherry

½ teaspoon Asian chile sauce

40 thin round gyoza or wonton wrappers

¼ cup cornstarch

3 tablespoons flavorless cooking oil

SAUCE

1 tablespoon minced basil leaves

1 tablespoon chopped cilantro sprigs

1 small whole green onion, minced

½ cup unsweetened coconut milk

¼ cup Chinese rice wine or dry sherry

1 tablespoon oyster sauce

1 teaspoon Asian chile sauce

½ teaspoon curry powder

½ teaspoon sugar

ADVANCE PREPARATION

In a bowl, combine the green onions, ginger, veal, oyster sauce, rice wine, and chile sauce. Mix thoroughly. Place 2 teaspoons filling in the center of a wrapper. (If using square wonton wrappers, trim them into circles.) Bring edges of wrapper up around filling and encircle the dumpling "waist" with your index finger and thumb. Squeeze the waist gently with that same index finger, while also pressing the top and the bottom of the dumpling with your other index finger and thumb. Line a baking sheet with parchment paper, dust paper heavily with cornstarch, place the dumplings on the baking sheet, and refrigerate uncovered.

Set aside the cooking oil. Combine all sauce ingredients and mix well. *All advance preparation steps may be completed up to 8 hours before you begin the final cooking steps.*

FINAL COOKING STEPS

Place a 12-inch nonstick sauté pan over high heat. Add cooking oil and immediately add dumplings bottom side down. Fry dumplings until bottoms become dark golden, about 2 minutes. Pour in sauce. Immediately cover pan, reduce heat to medium, and steam dumplings until they are firm to the touch, about 2 minutes. Shake the pan so that the dumplings "capsize" and are glazed all over with the sauce. Tip out onto a heated serving platter or 4 heated dinner plates. Serve at once.

SUGGESTED ACCOMPANIMENTS

Roasted baby beets, a Cobb salad, and raspberries with Grand Marnier truffles

Hot Pasta Tips

- Pasta and sauce are natural partners. Thin or smooth pastas such as spaghetti, linguine, and fettucine go with light, brothy sauces, cream sauces, and smooth tomato sauces, or with simple seasonings such as a combination of chopped fresh herbs, extra virgin olive oil, and grated cheese. Pastas that have ridges or twists (bow ties, shells, and elbows, for example) are best matched with robust, chunky sauces. The chunky sauces perfectly match the denser-textured pastas and cling better to the little folds, ridges, and ripples. There are exceptions. Tubular pasta such as penne works for both chunky sauces and for cream or tomato sauces, which fill the hollows. But don't be intimidated by rigid instructions and restrictions for pairing pastas and sauces. Use what you have in your cupboard and enjoy.

- When buying dried pasta, always check the package. If the package has any tears, the pasta may be spoiled. Also, don't buy dried pasta that is broken or fragmented. If the pasta has been poorly stored, it may be stale.

- Dried commercially made wheat pasta can be boiled hours in advance. This greatly simplifies the last-minute cooking. Boil the pasta. When the pasta is about 2 minutes from being perfectly cooked, drain the pasta. Immediately rinse thoroughly with cold water or transfer the pasta to a bowl of ice water and chill. Drain thoroughly and toss the pasta with 1 to 2 tablespoons of flavorless cooking oil. If completed more than 2 hours in advance of the final cooking, refrigerate the pasta. Store cooked pasta in the refrigerator no longer than 3 days. To use, the pasta only needs to be boiled for about 1 minute to reheat and finish cooking it.

Homemade pasta, whether fresh or dried, cannot be cooked ahead. Its delicate texture will cause the pasta to disintegrate during reheating.

Don't use homemade or fresh store-bought pasta for salads. The delicately textured pasta will disintegrate when mixed with the other salad ingredients.

We have been told that you can test pasta's doneness by throwing strands against the kitchen wall. More accurate but not always fail-safe are the recommended cooking times on the packaged pastas. Use the recommended cooking times as a rough guide. Dried pasta that has been recently manufactured has a moisture content of 12 percent; during storage, dried pasta continues to lose moisture, which makes it necessary to increase the cooking time.

To cook pasta perfectly, remove a strand every minute during the last 5 minutes of cooking and bite into it. Perfectly cooked pasta will have just lost its raw flour color in the center, and the pasta will be slightly resilient to the bite. *Al dente!*

To prevent burning your fingers and tongue when taste-testing strands of pasta, just drop a strand into a small bowl of cold water. Then you can pluck the pasta from the cold water and test the pasta without any discomfort.

Always undercook pasta that is destined for casseroles or soups, or that will be reheated later before being topped with a sauce.

When a recipe calls for combining boiled pasta with a sauce, just before draining the pasta, set aside 1 cup of the boiling pasta water, or have ready 1 cup of chicken stock. As you combine the cooked pasta with the sauce, if the sauce is too thick to coat the pasta, add a bit of the water or chicken stock.

● Always have ready 1 tablespoon cornstarch mixed with 1 tablespoon cold water. If the sauce appears watery, stir in a little of the cornstarch solution so that the sauce is *very slightly thickened*. Now the sauce will better glaze the pasta, and the pasta will have a more full flavor.

● To reheat pasta, use the microwave oven. Place the pasta in a microwave-safe bowl. If the pasta does not have much sauce, add ¼ to ½ cup water, chicken stock, or tomato sauce. Cover the bowl with plastic wrap, and heat over high power. Every 60 seconds, remove the bowl, stir the pasta briefly, cover again with the plastic wrap, and continue heating until piping hot.

● Another good way to reheat pasta is to place the pasta in a buttered casserole. If the pasta seems dry, moisten it with water, chicken stock, tomato sauce, milk, or cream. Sprinkle bread crumbs and/or grated cheese over the top. Bake uncovered in a preheated 350° oven until bubbling and golden on top. Depending on the quantity, this will take between 20 and 40 minutes.

● Nearly all pasta dishes are delicious cold. And all pasta dishes made without cream make delicious pasta salads. If the pasta has stuck together from being chilled, add a splash of water and warm briefly in the microwave oven. Then stir and taste the pasta. You may need to add a little olive oil or freshly chopped herbs to freshen the flavors.

*P*art of the fun of cooking is creating new variations on classic dishes. For this recipe, we make a rich lamb-tomato sauce infused with the flavors of ancho chiles, hoisin sauce, garlic, and basil. Then layers of the sauce, cheese, and flat sheets of pasta alternate in a baking dish. This lasagna is excellent made ahead and reheated, or eaten at room temperature for a picnic. As a variation, after cooking the sauce, toss it with 8 ounces of penne or fusilli pasta that is boiled and drained. Transfer this to a baking dish, sprinkle the top with 3 ounces of goat cheese, Parmesan, or sharp Cheddar, and bake in a 350° oven for 30 minutes.

Southwest Lamb Lasagna —————————————— *Serves 4 as the main entrée*

INGREDIENTS

6 pieces dried lasagna, each
 6½ x 3-inch pieces
½ pound part-skim ricotta cheese
½ cup grated pecorino or Reggiano
 Parmesan cheese

SAUCE

1 dried ancho chile (optional)
3 tablespoons extra virgin olive oil
4 cloves garlic, finely minced
¼ cup chopped shallots
½ pound medium-lean ground lamb
1 cup red wine
1 cup chicken stock
1 tablespoon hoisin sauce
2 tablespoons oyster sauce
2 teaspoons tomato paste
2 teaspoons Asian chile sauce
2 cups chopped vine-ripened tomatoes
 (about 5)
1 teaspoon finely minced orange zest
⅓ cup chopped cilantro sprigs

ADVANCE PREPARATION

Bring 4 quarts of water to a rapid boil. Lightly salt the water, then cook the pasta according to the instructions on the package. When the pasta loses its raw texture and is still slightly firm, about 15 minutes, remove from the heat, drain, rinse with cold water, and drain again. Lay the pasta in a single layer on a dampened kitchen towel. Combine the ricotta cheese with 3 tablespoons water, and stir until smooth. Set aside the pecorino.

To make the sauce, cover the chile with boiling water; after 30 minutes, stem, seed, and finely mince the chile. Set aside the oil, garlic, shallots, and lamb. In a bowl, combine the remaining sauce ingredients including the ancho. Place a 12-inch sauté pan over high heat and add the oil. When the oil becomes hot, add the garlic, shallots, and lamb. Using the back of a spoon, press the lamb against the sides of the pan until the meat breaks up into little grounds. Add the sauce. Bring to a low simmer, reduce the heat to medium, and cook until the sauce becomes

thick, about 15 to 20 minutes. Taste the sauce and adjust the seasonings, adding more chile sauce or oyster sauce as needed. Then cool the sauce to room temperature.

Spread a thin layer of the sauce evenly across the surface of a 9 x 9-inch baking dish. Add a single layer of pasta (2 pieces), spread on a thin layer of ricotta, and add a thin layer of the sauce and a sprinkling of pecorino. Add two more layers of pasta, ricotta, sauce, and pecorino. Cover and refrigerate. *All advance preparation steps may be completed up to 8 hours before you begin the final cooking steps.*

FINAL COOKING STEPS

Preheat the oven to 350°. Bake the lasagna for 20 to 30 minutes, uncovered, until the cheese and sauce are bubbling. Let stand for 5 minutes before cutting. Cut into pieces and transfer to 4 heated dinner plates. Serve at once.

SUGGESTED ACCOMPANIMENTS

A baby lettuce salad and peach sorbet with raspberry-cabernet sauce

This is a great recipe to make for large groups because the sauce can be made in advance and simply reheated before being spooned over the pasta. The special feature of this recipe is the Cajun roux, which is made by browning flour in oil until the flour turns a deep mahogany color. When the sauce is added to the roux, the sauce thickens and acquires a deep nutty flavor. Be sure to use chicken thigh meat rather than breast meat because the higher fat content of the thigh meat prevents the meat from becoming dry once the sauce is refrigerated and reheated.

Cajun Chicken Pasta

Serves 4 as the main entrée

INGREDIENTS

4 allspice berries

1 teaspoon mustard seeds

1 teaspoon cumin seeds

¼ teaspoon ground cayenne pepper

¼ cup extra virgin olive oil

¼ cup white flour

1 ounce pecorino or Reggiano Parmesan cheese

8 ounces dried pappardelle, fettucine, or your favorite pasta

¼ cup chopped parsley

SAUCE

8 chicken thighs, boned and skinned

6 cloves garlic, finely minced

⅓ pound andouille sausage, chopped

1 green bell pepper, seeded and chopped

¼ cup chopped parsley

¼ cup chopped oregano leaves

1 tablespoon chopped thyme leaves

1 cup seeded and finely chopped tomatoes

2 cups chicken stock

1 tablespoon red wine vinegar

2 teaspoons Worcestershire sauce

1 teaspoon tomato paste

½ teaspoon salt

¼ cup extra virgin olive oil

2 yellow onions, chopped

ADVANCE PREPARATION

Place the allspice, mustard, and cumin in a small sauté pan and toast the seasonings over medium heat until the mustard seeds begin to "pop." Transfer the spices to an electric spice grinder, add the cayenne, and grind into a powder. In separate containers, set aside the oil, flour, cheese, pasta, and parsley.

To make the sauce, cut each chicken thigh into 8 pieces, rub the chicken pieces with the spice blend, and refrigerate. Combine the garlic, andouille, and pepper. In a bowl, combine the parsley with all the remaining sauce ingredients except the oil and onions.

Place a 12-inch sauté pan over medium heat. Add the oil and the onions. Sauté the onions until they brown. Add the chicken, garlic, andouille, and pepper. Cook until the chicken loses all of its raw color on the outside. Add the other combined sauce ingredients and simmer until the chicken is just cooked through, about 3 minutes.

Transfer all the ingredients to a bowl, and return the sauté pan to medium heat. Add the reserved ¼ cup oil and the flour. Stir continuously with a whisk until the flour becomes mahogany colored. Immediately return the sauce to the pan. Bring to a simmer and cook until the sauce thickens enough to lightly coat a spoon. Let the sauce cool. If the sauce is made more than 1 hour in advance of serving, transfer to a bowl, cool, and refrigerate. *All advance preparation steps may be completed up to 8 hours before you begin the final cooking steps.*

FINAL COOKING STEPS

Grate the cheese, about ¼ cup. Bring 4 quarts of water to a rapid boil. Lightly salt the water, then cook the pasta according to the instructions on the package. When the pasta loses its raw texture but is still slightly firm, remove from the heat and drain. Transfer the pasta to a heated platter or 4 heated dinner plates.

Meanwhile, reheat the sauce, bringing it to a low simmer. Taste and adjust the seasonings, especially for salt. If the sauce is very thick, thin it by adding a little more chicken stock, white wine, or water. Spoon the sauce over the pasta. Sprinkle on the cheese and the reserved parsley. Serve at once.

SUGGESTED ACCOMPANIMENTS

A Bibb lettuce salad with toasted pine nuts and a chocolate banana cream tart

In creating this pasta recipe with Moroccan flavors, we looked for flavor combinations characteristic of that country, namely, honey, lemon, paprika, crushed red pepper, cilantro, and mint, along with ingredients found in many typical dishes, such as toasted pine nuts and olives. Although this recipe uses raw chicken, you can simplify the recipe by substituting barbecued or roasted chicken, or by omitting the chicken for a vegetarian pasta dish.

Pasta Marrakech
Serves 4 as the main entrée

INGREDIENTS

1 pound chicken breast halves, boned and skinned

1 cup low-brine black olives, pitted

½ cup pine nuts

8 ounces dried corkscrews, fusilli, or your favorite pasta

2 tablespoons extra virgin olive oil

¼ cup chopped parsley

1 whole nutmeg

SAUCE

5 cloves garlic, finely minced

2 tablespoons very finely minced ginger

⅓ cup chopped cilantro sprigs

⅓ cup chopped mint leaves

⅓ cup chicken stock

⅓ cup freshly squeezed lemon juice

2 tablespoons honey

2 teaspoons ground cumin

2 teaspoons sweet paprika

2 teaspoons cornstarch

½ teaspoon crushed red pepper flakes

ADVANCE PREPARATION

Preheat the oven to 325° (for toasting the pine nuts). Cut chicken breasts lengthwise into ¼-inch-wide strips, then cut the strips crosswise in 1-inch lengths. Split the olives in half lengthwise, and set them aside. Toast the pine nuts in the preheated oven until golden, about 8 minutes. Set aside the pasta, olive oil, parsley, and nutmeg. In a bowl, combine all the sauce ingredients. Stir well, then add 3 tablespoons to the chicken; mix thoroughly and refrigerate. Refrigerate remaining sauce. *All advance preparation steps may be completed up to 8 hours before you begin the final cooking steps.*

FINAL COOKING STEPS

Bring 4 quarts of water to a rapid boil. Lightly salt the water, then cook the pasta according to the instructions on the package. When the pasta loses its raw texture but is still slightly firm, remove from the heat and drain.

Meanwhile, place a 12- or 14-inch sauté pan over high heat. When the pan becomes hot, add the olive oil. When the oil gives off a wisp of smoke, add the chicken. Stir and toss the chicken until it loses its raw outside color.

Add the pasta, olives, pine nuts, and sauce. Stir and toss until evenly combined and well heated. Taste and adjust the seasonings, especially for salt. Transfer the pasta to a heated platter or 4 heated dinner plates and sprinkle parsley. Grate a little nutmeg across the surface of the pasta. Serve at once.

SUGGESTED ACCOMPANIMENTS

Roasted stuffed tomatoes, a tropical papaya salad, and an almond-raspberry torte

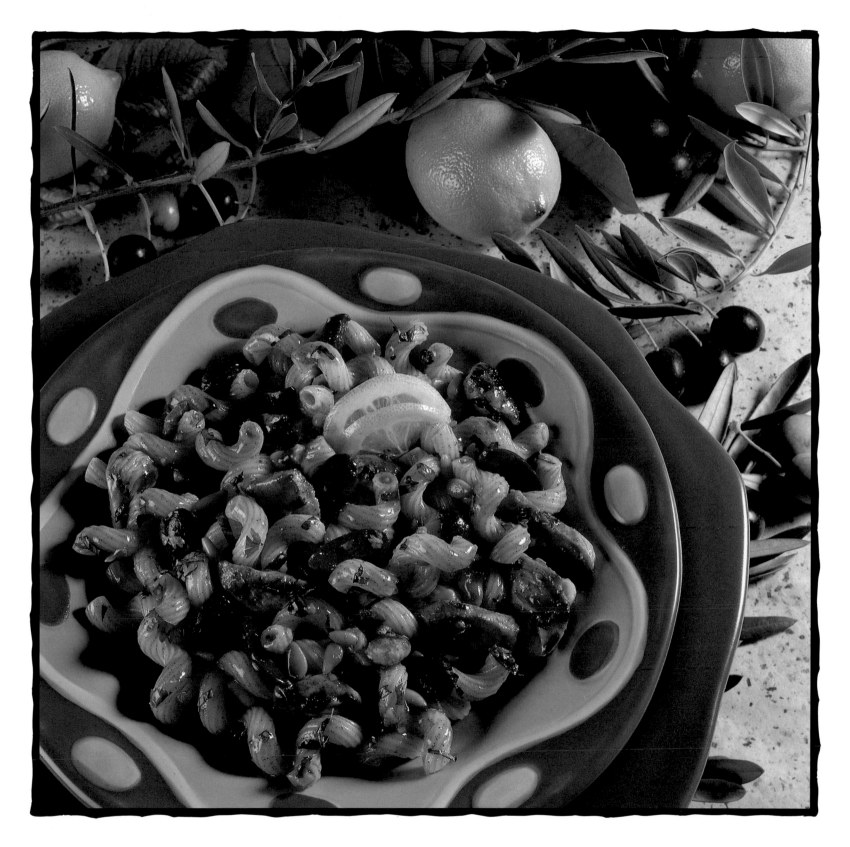

This dish, one of the most famous pasta dishes from Szechwan, is made by stir-frying the translucent Chinese noodles (the tree) with slivered or ground pork (the ants), seasoning the noodles with copious amounts of garlic chile sauce (the bark), and adding a fistful of chopped cilantro (the leaves) during the final seconds of cooking. Excellent hot or cold, this dish should cause your eyelids to perspire.

Ants Climbing the Tree

Serves 4 as a side dish

INGREDIENTS

4 ounces bean threads, or 8 ounces dried spaghetti

2 to 4 tablespoons flavorless cooking oil

½ pound ground pork or lamb

4 whole green onions, minced

⅓ cup cilantro sprigs

SAUCE

8 cloves garlic, finely minced

1 tablespoon very finely minced ginger

⅓ cup chicken stock

¼ cup Chinese rice wine or dry sherry

1 tablespoon oyster sauce

1 tablespoon hoisin sauce

1 tablespoon dark sesame oil

2 teaspoons Asian chile sauce

2 teaspoons cornstarch

ADVANCE PREPARATION

Place the bean threads in a bowl and add enough boiling water to completely cover all the bean threads. Soak the bean threads for 30 minutes. Then drain thoroughly and cut the bean threads into approximately 6-inch lengths; refrigerate. (If using spaghetti, cook according to the instructions on the package, then drain, rinse with cold water, and drain again. Toss the spaghetti with 2 tablespoons of the cooking oil.)

In separate containers, set aside the pork, green onions, and cilantro. In a small bowl, combine 2 tablespoons of the cooking oil with the garlic and ginger. In another bowl, combine all the remaining sauce ingredients; refrigerate. *All advance preparation steps may be completed up to 8 hours before you begin the final cooking steps.*

FINAL COOKING STEPS

Chop the cilantro. Stir the sauce. Place a wok over high heat. When hot, add the oil-garlic mixture. Sauté until the garlic begins to sizzle but has not browned. Add the pork. Using the back of a spoon, break the pork into individual grounds, about 1 minute.

When the pork loses all of its raw color, add the bean threads, green onions, cilantro, and the sauce. Stir and toss until evenly combined and well heated. Taste and adjust the seasonings, especially for salt. Transfer the pasta to a heated platter or 4 heated dinner plates. Serve at once.

SUGGESTED ACCOMPANIMENTS

Hot and sour soup, a Chinese chicken salad with hazelnuts, and bananas flambé

One of the quickest and most delicious ways to create main course pasta dishes is to combine leftover stews, pot roasts, or curries that are reheated with just-cooked pasta. For example, here lamb shanks are simmered with root vegetables in a rich red wine-garlic sauce. Hours or even days later, this makes a terrific topping for homemade or commercial pasta. To speed up the preparation, be sure to have the butcher bone the lamb shanks.

Pasta with Lamb Shanks

Serves 4 as the main entrée

INGREDIENTS

1½ pounds lamb shank meat (about 4 to 6 shanks)

½ pound shiitake or chanterelle mushrooms

16 baby carrots, tops trimmed

12 baby beets, tops trimmed

8 ounces dried fusilli, penne, or your favorite pasta

¼ cup olive oil

½ cup parsley

2 teaspoons cornstarch

SAUCE

8 cloves garlic, finely minced

2 cups red wine

1 cup chicken stock

1 cup tomato sauce

¼ cup hoisin sauce

2 tablespoons oyster sauce

½ teaspoon Asian chile sauce

¼ cup chopped oregano leaves

ADVANCE PREPARATION

Cut the lamb into bite-sized pieces. Cut the stems off the shiitake mushrooms. (If using chanterelles, wipe the chanterelles with a damp paper towel.) Then thinly slice the mushrooms. Scrub the carrots, then cut in half on a sharp diagonal. Scrub the beets. In separate containers, set aside the pasta, oil, parsley, and cornstarch.

To make the sauce, set aside the garlic and set aside ½ cup of the red wine. In a bowl, combine all the remaining sauce ingredients, and stir well.

Place a 12- or 14-inch sauté pan over high heat. When hot, add the oil. When the oil becomes hot, add the lamb. Stir and toss the lamb until it loses all of its raw color on the outside. Add the garlic, mushrooms, and the ½ cup of red wine. Cook the mushrooms until they decrease significantly in volume, about 4 minutes. Add the carrots, beets, and sauce. Bring the sauce to a low boil, cover the pan, turn down the heat to very low, and simmer the lamb until it is tender, about 30 to 45 minutes. If the sauce is made more than 1 hour in advance of serving, refrigerate. *All advance preparation steps may be completed up to 8 hours before you begin the final cooking steps.*

FINAL COOKING STEPS

Chop the parsley. Combine the cornstarch with 2 teaspoons cold water. Bring 4 quarts of water to a rapid boil. Lightly salt the water, then cook the pasta according to the instructions on the package. When the pasta loses its raw texture but is still slightly firm, remove from the heat and drain.

Reheat the lamb in a 12- or 14-inch sauté pan. Add the pasta and half the parsley. Stir and toss until evenly combined and well heated. If the sauce is watery, stir in the cornstarch mixture. Taste and adjust the seasonings. Transfer the pasta to a heated platter or 4 heated dinner plates. Sprinkle on the remaining parsley and serve at once.

SUGGESTED ACCOMPANIMENTS

Baby lettuce greens with toasted pecans and chocolate crème brûlée

he secret to all good tomato sauces is using vine-ripened tomatoes, and then simmering the sauce for at least 30 minutes to both mellow and harmonize the flavors. The sauce can be made several days in advance, or made in larger quantities and then frozen. The special ingredient in this recipe is dried ancho chiles. Their slightly spicy, fruity taste lends a captivating undercurrent of flavor. Look for dried ancho chiles in Mexican markets, specialty gourmet shops, and supermarkets that carry a wide selection of dried chiles.

Pasta with Rich Tomato-Beef Sauce

Serves 4 as the main entrée

INGREDIENTS

2 ounces pecorino or Reggiano
 Parmesan cheese

½ cup parsley sprigs

2 teaspoons cornstarch

8 ounces dried large shells, fusilli, or your
 favorite pasta

SAUCE

½ pound beef chuck, lamb shoulder
 meat, or pork from country-style ribs

2 tablespoons extra virgin olive oil

¼ cup chopped shallots

1 yellow onion, chopped

5 cloves garlic, finely minced

1 tablespoon very finely minced ginger

3 cups seeded and chopped vine-
 ripened tomatoes

2 dried ancho chiles (optional), seeded
 and chopped

2 cups red wine or chicken stock

1 tablespoon tomato paste

1 teaspoon salt

¼ teaspoon crushed red pepper flakes

¼ cup chopped basil leaves

2 tablespoons chopped oregano leaves

2 tablespoons chopped thyme

ADVANCE PREPARATION

Set aside the cheese, parsley, cornstarch, and pasta.

To make the sauce, cut the meat into slivers 1 inch long by ⅛ inch thick. Place a 12- or 14-inch sauté pan over medium heat and add the oil. When the oil becomes hot, add the shallots and onion. Sauté until they become a deep golden color, about 10 minutes. Add the garlic, ginger, and meat. Sauté until the meat loses all of its raw color. Add the remaining sauce ingredients. Bring to a low boil, then reduce the heat to low and simmer partially covered until the meat is tender and the sauce thickens. If the sauce is made more than 1 hour in advance of serving, cool, transfer to a bowl, and refrigerate. *All advance preparation steps may be completed up to 1 day before you begin the final cooking steps.*

FINAL COOKING STEPS

Shred the cheese, about ½ cup. Chop the parsley. Combine the cornstarch with 2 teaspoons cold water. Bring 4 quarts of water to a rapid boil. Lightly salt the water, then cook the pasta according to the instructions on the package. When the pasta loses its raw texture but is still slightly firm, remove from the heat and drain.

Meanwhile, reheat the sauce. Taste and adjust the seasonings, especially for salt. If the sauce appears a little watery, stir in the cornstarch mixture. Transfer the pasta to a heated platter or 4 heated dinner plates. Spoon the sauce over the pasta. Sprinkle on the cheese and parsley. Serve at once.

SUGGESTED ACCOMPANIMENTS

Garden greens with balsamic dressing and butter pecan ice cream with a raspberry-cabernet sauce

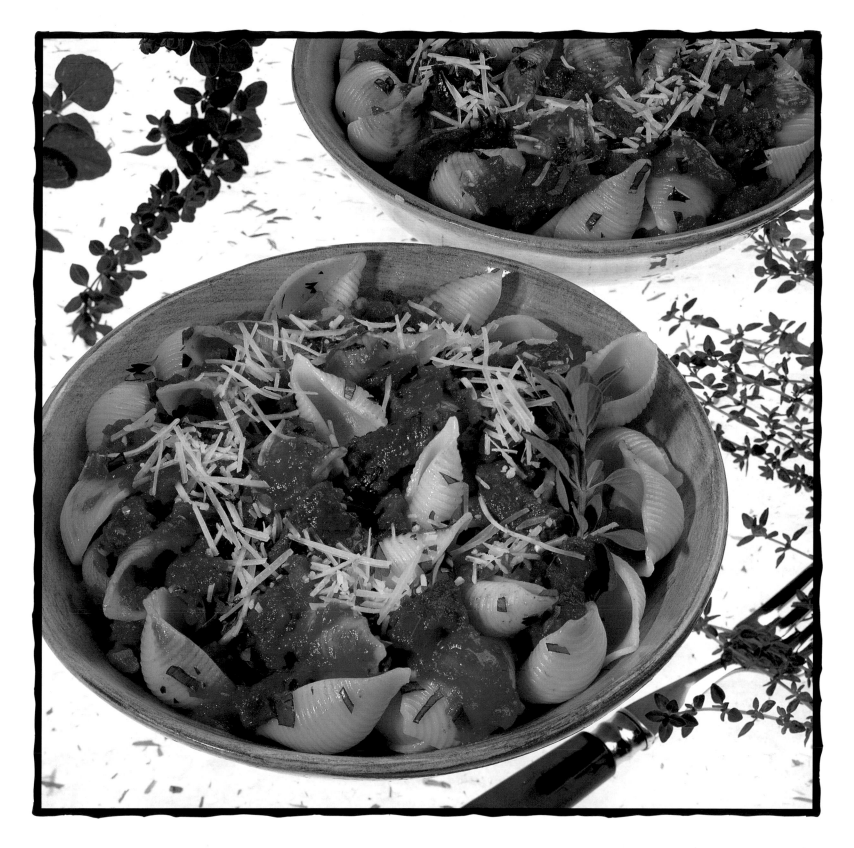

The rich ricotta cheese–pesto filling hiding in these ravioli is perfectly accented by the assertively seasoned lamb-tomato-garlic sauce. The sauce can be made up to 5 days in advance. However, because it thickens in the refrigerator, add a little chicken stock to the sauce as it reheats. The ravioli taste inferior if they are made ahead and frozen. We make the filling a day ahead or in the morning, and then invite our dinner guests to participate in assembling the ravioli. Everyone loves the activity, and we are spared hours of solitary assembly!

Ricotta Ravioli with Garlic-Lamb Essence

Serves 4 as the main entrée

INGREDIENTS

2 ounces Reggiano Parmesan cheese

3 whole green onions, minced

¾ pound ricotta cheese

⅓ cup pesto sauce, homemade or
 store-bought

1 egg yolk

¼ teaspoon salt

60 thin round gyoza or wonton
 wrappers

2 eggs, beaten

¼ cup cornstarch

⅓ cup cilantro sprigs

SAUCE

3 tablespoons extra virgin olive oil

1 small yellow onion, chopped

5 cloves garlic, finely minced

½ pound ground lamb

4 vine-ripened tomatoes, seeded and
 minced

1 cup chicken stock

1 tablespoon hoisin sauce

1 tablespoon oyster sauce

1 teaspoon Asian chile sauce

ADVANCE PREPARATION

Grate the Reggiano Parmesan cheese, about ½ cup. In a bowl, combine the green onions, cheeses, pesto sauce, egg yolk, and salt. Mix thoroughly. Place 2 teaspoons of the filling in the center of a wrapper. (If using square wonton wrappers, trim them into circles.) Moisten the edge with a little beaten egg. Place another wrapper on top and firmly press the wrappers together to tightly seal. Repeat with the remaining ravioli. Line a baking sheet with parchment paper, dust paper heavily with cornstarch, place ravioli in a single layer on the baking sheet, and refrigerate uncovered. Set aside the cilantro.

To make the sauce, place a 12-inch sauté pan over medium heat. Add the oil and onion. Sauté the onion until it becomes dark golden, about 10 minutes. Add the garlic and lamb. Using the back of a spoon, press the lamb against the bottom of the pan to break it into individual grounds. When the lamb is thoroughly cooked, about 3 minutes, add the remaining sauce ingredients. Bring to a simmer and cook until the sauce becomes thick enough to lightly coat a spoon, about 10 minutes. If the sauce is made more than 1 hour in advance of serving, transfer to a bowl, cool, and refrigerate. *All advance preparation steps may be completed up to 8 hours before you begin the final cooking steps.*

FINAL COOKING STEPS

Chop the cilantro. In a sauté pan or saucepan, reheat the sauce. Taste and adjust the seasonings. Keep the sauce at a simmer.

Bring 4 quarts of water to a rapid boil. Lightly salt the water, then add in the ravioli. As soon as the ravioli rise to the surface, about 45 seconds, gently transfer them to a colander to drain briefly. Transfer the ravioli to a heated platter or 4 heated dinner plates. Spoon the sauce over the ravioli, and sprinkle on the cilantro. Serve at once.

SUGGESTED ACCOMPANIMENTS

A salad of baby greens dressed with walnut oil and a lemon meringue pie.

When tough cuts of meat are simmered for hours, they make rich, complex-tasting toppings for pasta. This recipe uses veal shanks, but equally good are lamb shanks and shoulder, or boneless country-style pork spareribs. The meat can be cooked in the morning or even a day ahead. Then all you have to do is bring the rich-tasting sauce to a simmer and spoon it over the just-cooked pasta.

Pasta with Braised Veal Shanks

Serves 4 as the main entrée

INGREDIENTS

6 veal shanks

Salt and pepper to taste

½ cup white flour

⅓ cup olive oil

2 yellow onions

5 parsnips

6 carrots

¾ cup parsley sprigs

2 ounces pecorino or Reggiano Parmesan cheese

1 tablespoon cornstarch

8 ounces dried fettucine, linguine, or your favorite pasta

SAUCE

2 cups chicken stock

2 cups red wine

¼ cup oyster sauce

2 tablespoons dark sesame oil

1 tablespoon tomato paste

2 teaspoons sugar

1 teaspoon freshly ground black pepper

6 cloves garlic, finely minced

2 tablespoons very finely minced ginger

ADVANCE PREPARATION

Preheat the oven to 325°. Set aside the veal, salt, pepper, flour, and oil. Cut the onion into ½-inch cubes. Peel the parsnips and carrots, then cut on a diagonal into 1-inch pieces. In separate containers, set aside the parsley, cheese, cornstarch, and pasta. In a small bowl, combine all the sauce ingredients and stir well.

Place a 12-inch ovenproof braising pot over medium heat. Add the oil. Sprinkle both sides of the veal with salt and pepper and then with flour. Shake off all excess flour, and when the oil becomes hot, add the veal shanks to the braising pot. Cook the shanks on both sides until well browned, then temporarily remove from the pot.

Add the onions and sauté until they become translucent. Return the veal to the pot, add the parsnips and carrots, and add the sauce. Bring the sauce to a low simmer; then cover the pot and transfer to the oven. Cook in the oven until the veal is tender, about 90 minutes. When tender, remove the pot from the oven. Pull the meat from the bone and cut into bite-sized pieces. Scoop the marrow from the bones and mix into the sauce, then discard the bones. Cool to room temperature. If the stew is made more than 2 hours before serving, refrigerate. *All advance preparation steps may be completed up to 8 hours before you begin the final cooking steps.*

FINAL COOKING STEPS

Bring the veal stew to a simmer. Chop the parsley. Grate the cheese, about ½ cup. Combine the cornstarch with 1 tablespoon cold water. If the sauce appears very thin, stir in enough of the cornstarch mixture to thicken it slightly.

Bring 4 quarts of water to a rapid boil. Lightly salt the water, then cook the pasta according to the instructions on the package. When the pasta loses its raw texture but is still slightly firm, remove from the heat and drain.

Transfer the pasta to a heated platter or 4 heated dinner plates. Spoon veal stew over the pasta. Sprinkle with cheese and parsley and serve at once.

SUGGESTED ACCOMPANIMENTS

A watercress salad and a hot apple crisp with bourbon ice cream

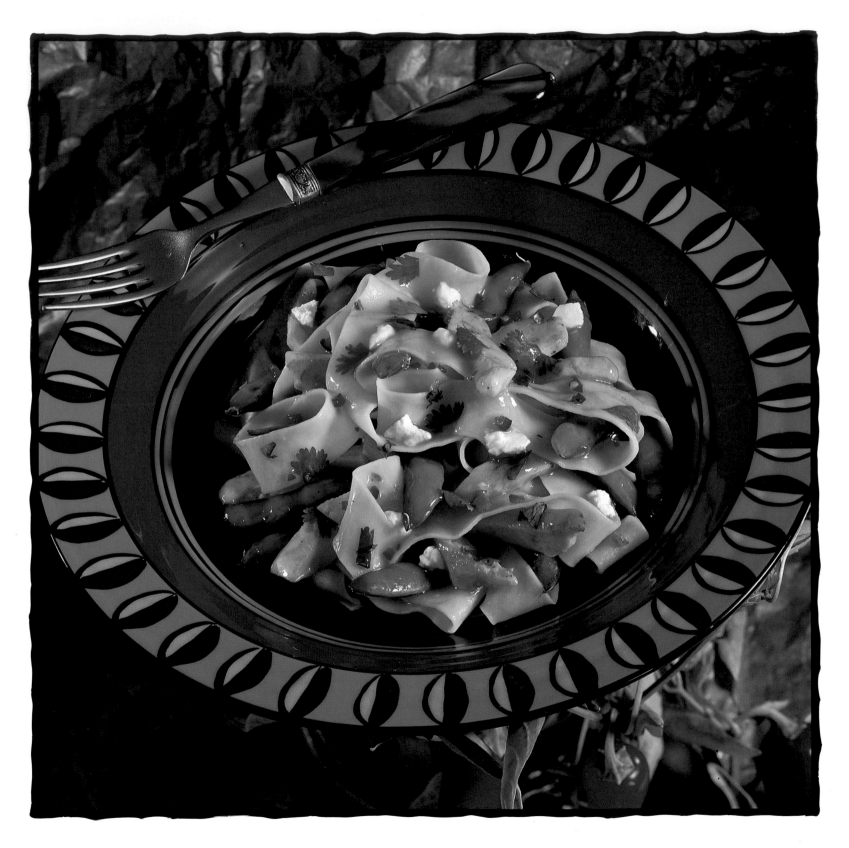

This pasta dish gains its wide range of flavors from the use of fresh chiles, goat cheese, cilantro, and smoked chicken. If small whole smoked chickens or locally smoked chicken breasts are unavailable, rather than using the mass-produced, mediocre-tasting smoked chicken (or turkey) "loaves," substitute 1 pound of meat from a barbecued or roasted chicken. Or replace the smoked chicken with an equivalent amount of raw, shelled, and deveined medium shrimp. Sauté the shrimp with sugar snap peas until the shrimp lose their raw outside color, and then proceed with the recipe directions.

Southwest Pasta with Smoked Chicken

Serves 4 as the main entrée

INGREDIENTS

¼ cup extra virgin olive oil

4 cloves garlic, finely minced

¼ cup minced shallots

1 to 2 fresh serrano chiles, finely minced including the seeds

1 pound smoked, boned chicken

3 cups sugar snap peas or snow peas

1 cup chicken stock

1 tablespoon oyster sauce

2 teaspoons cornstarch

½ cup loosely packed cilantro sprigs

2 tablespoons oregano leaves

3 ounces goat cheese

8 ounces dried pappardelle, tagliatelle, or your favorite pasta

Salt to taste

ADVANCE PREPARATION

In a small container, combine the oil, garlic, shallots, and chiles, then set aside. Cut the chicken into matchstick-shaped pieces about ¼ inch wide and 1 inch long, then refrigerate. Set aside the sugar snap peas. In a small bowl, combine the stock, oyster sauce, and cornstarch, then refrigerate. Combine the cilantro and oregano and refrigerate. Crumble the goat cheese, then refrigerate. Set aside the pasta. *All advance preparation steps may be completed up to 8 hours before you begin the final cooking steps.*

FINAL COOKING STEPS

Chop the cilantro and oregano. Bring 4 quarts of water to a rapid boil. Lightly salt the water, then cook the pasta according to the instructions on the package. When the pasta loses its raw texture but is still slightly firm, remove from the heat and drain.

Return the empty pasta pot to the stove over high heat. Add the oil-garlic mixture and sauté until the garlic begins to sizzle but has not browned. Add the chicken and sugar snap peas. Sauté until the peas brighten, about 2 minutes. Add the chicken stock mixture and bring to a low boil. Add the pasta. Stir and toss until evenly combined and well heated. Stir in the goat cheese and herbs, and mix briefly. Taste and adjust the seasonings, especially for salt. Transfer the pasta to a heated platter or 4 heated dinner plates. Serve at once.

SUGGESTED ACCOMPANIMENTS

A crab gazpacho, watercress and pecan salad, and raspberry crème brûlée

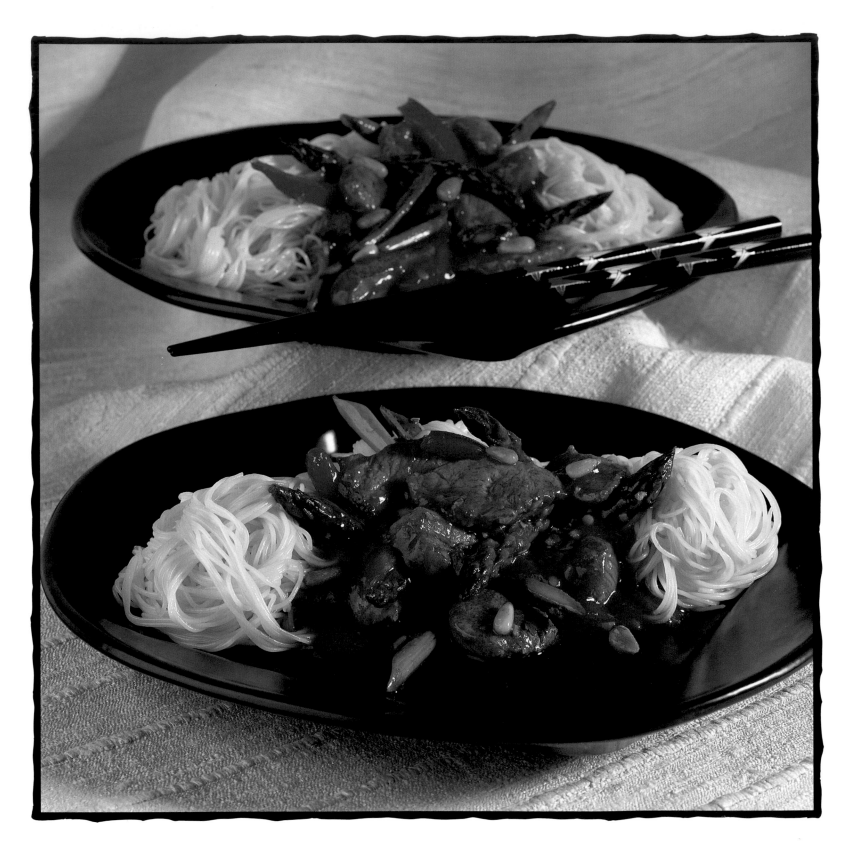

All stir-fry dishes make great toppings for pasta. This recipe uses little bundles of angel hair "nests," but any thin spaghetti-style pasta will work well as a substitute. When cooking the angel hair nests, stir the nests carefully in the boiling water, gently transfer them to heated dinner plates, and using a large fork, twirl the pasta into attractive nests.

Angel Hair Pasta with Duck

Serves 4 as the main entrée

INGREDIENTS

1 pound duck meat, from the breast or from a whole duck

14 stalks thin asparagus

1 red bell pepper

3 whole green onions

½ cup pine nuts

4 cloves garlic, finely minced

1 tablespoon very finely minced ginger

¼ cup flavorless cooking oil

8 ounces dried angel hair, fettucine, or your favorite pasta

SAUCE

¼ cup Chinese rice wine or dry sherry

2 tablespoons tomato sauce

2 tablespoons oyster sauce

1 tablespoon hoisin sauce

1 tablespoon dark sesame oil

2 teaspoons white wine vinegar

1 teaspoon Asian chile sauce

2 teaspoons cornstarch

1 teaspoon finely minced tangerine zest, plus ½ cup tangerine juice

¼ cup chopped cilantro sprigs

ADVANCE PREPARATION

Preheat the oven to 325° (to toast the pine nuts). Cut the duck meat into matchstick-shaped pieces about 1 inch long and ⅛ inch thick. Place duck in a small bowl and set aside. Snap ends off the asparagus, then cut the asparagus on a very sharp diagonal into 1- to 2-inch pieces. Seed, stem, and cut the pepper into strips 1 inch long and ¼ inch wide. Shred the green onions. Combine the vegetables and refrigerate.

Toast the pine nuts in the preheated oven until golden, about 8 minutes. Combine garlic, ginger, and cooking oil. Set aside pasta. In a small bowl, combine all sauce ingredients. Add 2 tablespoons of the sauce to the duck, mix thoroughly, then refrigerate the duck. *All advance preparation steps may be completed up to 8 hours before you begin the final cooking steps.*

FINAL COOKING STEPS

Bring 4 quarts of water to a rapid boil. Lightly salt the water, then cook the pasta according to the instructions on the package. When the pasta loses its raw texture but is still slightly firm, remove from the heat and drain.

Meanwhile, place a wok over high heat. When hot, add half the oil-garlic mixture. When the oil just gives off a wisp of smoke, add the duck. Stir and toss until the duck just loses its raw outside color, about 2 minutes. Transfer the duck to a plate. Immediately return the wok to high heat. Add the remaining oil mixture and the vegetables. Stir-fry the vegetables until they brighten, about 2 minutes.

Return the duck to the wok and pour in the sauce. Bring the sauce to a low boil; stir in the pine nuts. Taste and adjust the seasonings. Twirl the pasta into "nests" and place on a heated platter or 4 heated dinner plates. Spoon the duck on top of the pasta nests. Serve at once.

SUGGESTED ACCOMPANIMENTS

An endive and watercress salad and a warm blueberry tart

Pasta Triumphs with Butter, Cream, and Cheese

In this age of calorie marshals, fat patrols, and the nutritional mafia, it's even more exciting to sneak one of these recipes onto the table and observe the wild enthusiasm and unabashed requests for multiple servings. Here you will find classic combinations such as pasta with Gorgonzola-walnut sauce, and pasta glazed with cream, Parmesan, and smoked salmon. But many of the recipes provide a twist such as macaroni with five cheeses, a lemon-cream sauce infused with Asian chile sauce, and an Italian seafood cream sauce intensely flavored with cilantro.

Key Pasta Techniques with Dairy Products

The following recommendations are for 8 ounces of dried commercially made pasta.

Butter: Use up to ½ pound of unsalted butter. Use only 1 to 2 tablespoons butter if adding cream or generous amounts of cheese. Browning the butter lightly in the sauté pan adds an intriguing nutty flavor to the pasta. Never use any butter substitutes; they will ruin the taste of the dish.

Heavy cream: Just a few additional tablespoons of cream will add a wonderful richness to pasta dishes. Substituting lowfat or regular milk contributes nothing to the taste of the pasta. Add only 1 tablespoon of heavy cream at a time to sauces with a dominant Asian-style or citrus base because discordant flavors can develop.

Sour cream and crème fraîche: A few tablespoons of either of these can add a pleasant nutty, slightly sour taste to the pasta. To make your own crème fraîche: Mix 1 cup heavy cream with 2 tablespoons buttermilk. Let the mixture sit in a warm place for 24 hours, then refrigerate for at least 4 hours. Discard after 10 days.

Cheeses: Add up to 8 ounces of crumbled goat cheese, blue cheese, or any of the French triple-cream cheeses. Stir with the pasta until nearly completely melted. Up to 4 ounces of any of the aged hard European cheeses, such as pecorino, Asiago, or Reggiano Parmesan, contribute wonderful additional flavors to virtually all pasta recipes, whether traditional or innovative.

Because veal is lean, it toughens when refrigerated. So plan on completing the cooking of this veal stew just before your guests arrive, keep it warm on the back burner, and then when you are ready to serve the entrée, incorporate it into just-cooked pasta. We have substituted boneless, skinless chicken thigh meat (more flavorful and tender than breast meat) and meat from country-style spareribs with equal success.

Pasta with Veal, Cream, and Basil

Serves 4 as the main entrée

INGREDIENTS

1½ pounds veal stew meat, preferably from the shank

½ pound mushrooms (such as chanterelles, portobellos, or shiitakes)

½ pound button mushrooms

8 ounces dried straw and hay linguine, spinach fettucine, or your favorite pasta

2 ounces pecorino or Reggiano Parmesan cheese

½ cup parsley sprigs

SAUCE

¼ cup extra virgin olive oil

4 cloves garlic, finely minced

½ cup chopped shallots

½ cup white wine

¾ cup chicken stock

¾ cup heavy cream

2 tablespoons oyster sauce

½ teaspoon freshly ground black pepper

½ cup chopped basil leaves

ADVANCE PREPARATION

Cut the meat across the grain in ¼-inch-wide slices. Discard the shiitake stems. Cut the mushrooms into ¼-inch slices. In separate containers, set aside the pasta, cheese, and parsley. In a small bowl, combine oil, garlic, and shallots. In a bowl, combine all the remaining sauce ingredients.

Place a 12- or 14-inch sauté pan over high heat. When hot, add the oil mixture. When the oil becomes hot and the garlic begins to sizzle, add the meat. Stir and toss until the meat loses its raw outside color, about 3 minutes. Add the mushrooms. Sauté the mushrooms over medium heat until they shrink in size by one-half, about 5 minutes.

Add the sauce. Bring the sauce to a boil, cover, and simmer until the veal is tender, about 30 minutes. The veal stew can be set aside at room temperature for up to 1 hour or refrigerated. *All advance preparation steps may be completed up to 8 hours before you begin the final cooking steps.*

FINAL COOKING STEPS

Grate the cheese, about ½ cup. Mince the parsley. Bring 4 quarts of water to a rapid boil. Lightly salt the water, then cook the pasta according to the instructions on the package. When the pasta loses its raw texture but is still slightly firm, remove from the heat and drain.

In a large sauté pan, reheat the veal stew. Add the pasta. Stir and toss until evenly combined and well heated. Stir in the cheese. Taste and adjust the seasonings, especially for salt and pepper. Transfer the pasta to a heated platter or 4 heated dinner plates. Sprinkle with parsley and serve at once.

SUGGESTED ACCOMPANIMENTS

A radicchio salad with walnut oil and a lemon fudge cake

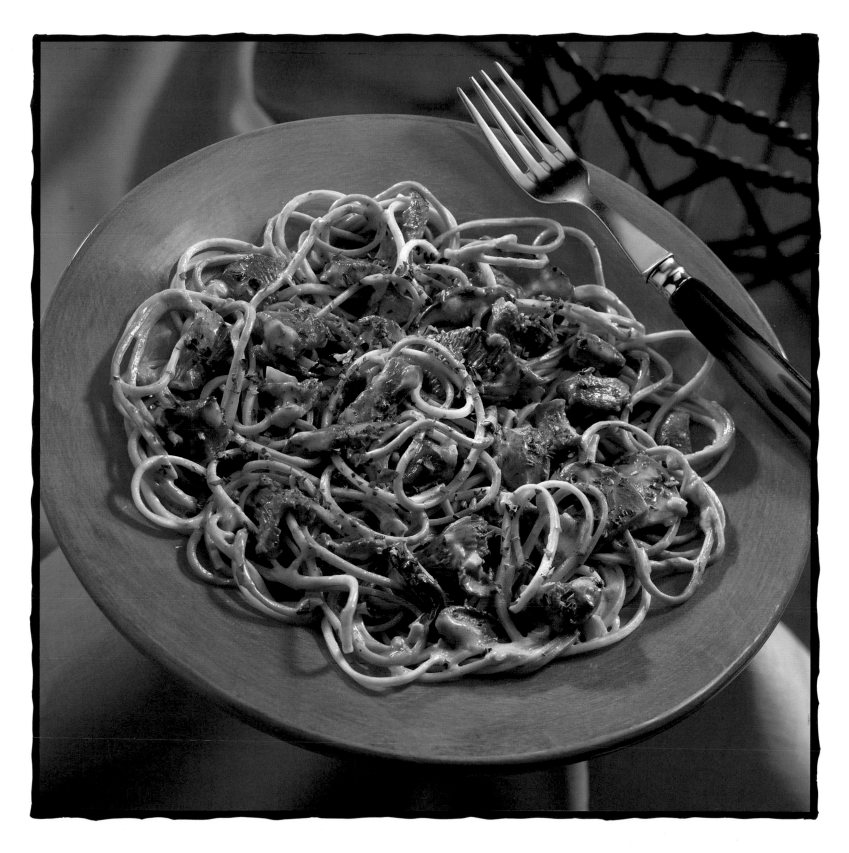

O nce upon a time in the age when pasta masters had only rolling pins, making homemade pasta was an art. Cooks rolled perfectly made pasta dough on huge tables, and gradually stretched the dough into vast sheets to be cut, boiled, and topped with divine sauces.

How to Make Perfect Homemade Hot Pasta

Now for the first time an age of equal opportunity for pasta making has arrived for all who crave paper-thin, silky-textured, homemade pasta. This type of pasta has an extraordinary sensual texture and cooks in seconds because the pasta is made with all-purpose unbleached white flour rather than the durum wheat semolina used for most commercially made pasta. Waste no time with rolling pins or electric pasta machines that knead and extrude the dough. Rolling pins require a practiced technique, while machine-made extruded pasta has a leaden texture and coarse taste. With one of the manual pasta machines described on page 21, you'll enjoy remarkable results.

Basic Homemade Pasta

Serves 4

3 large eggs

2 ¼ cups all-purpose unbleached flour

To make the dough by hand: Place the flour in a bowl and make a well in the center. Add the eggs to the well. Using a fork, thoroughly incorporate the eggs into the flour. Turn the dough onto a wooden board (working the dough on a cold tile or Formica counter makes it much stiffer and more difficult to knead). Knead the dough until smooth and silky, about 5 min-

utes. You should not need to add any flour. The dough will feel very stiff. If it feels impossibly stiff, work in a few drops of water. Once you form the dough into a ball, with a dough scraper, scrape up and discard all the dough fragments (they will be tough). When the dough becomes smooth and silky, immediately wrap it in plastic and let it rest at room temperature at least 20 minutes and as long as 3 hours. As the dough rests, it become much more pliable. Do not refrigerate the dough; refrigeration prevents it from developing the right texture.

To make the dough in a food processor: Place the flour and the beaten egg into a processor and process into a ball. Remove the dough and knead until smooth and silky feeling. Wrap with plastic.

To roll out the pasta by machine: Cut the dough into 4 to 6 pieces, and cover all the pieces except one. Flatten one piece into a thin layer. Position the rollers at their widest setting (#1 setting). Crank the dough through. Fold the dough in thirds and crank it through again. Do this several times, or until the dough feels very smooth. Only dust dough with flour if it feels sticky. Repeat the rolling process with the remaining pieces.

Reduce the width of the rollers by one setting. Run all the pieces through this setting once. Then reduce the width of the rollers again. Repeat this, running the dough through each setting only once until all the pieces have been put through the finest setting (#6 or #7). As each strip is completed, lay the dough on a dry kitchen towel.

To cut the dough: Rather than using the pasta cutters included with the machine, we prefer cutting the pasta sheets using a knife or a fluted wheel because it gives the pasta a more homemade look. Place the pasta sheets on a lightly floured surface, and cut to desired widths.

To store homemade pasta: If you are not cooking the pasta immediately, toss small amounts of pasta with a little flour, place the pasta on dry towels and allow to dry. The pasta can be cooked any time during the drying process. Once the pasta has dried for 6 hours, place it in an airtight container and store at room temperature. Use within 1 month.

Colored Pastas

We only provide recipes for a green pasta and a red pasta because all the other colored and flavored pastas are disappointing in color, taste, and texture.

Spinach Pasta: For each egg, use 4 ounces of fresh spinach leaves. Submerge the spinach in boiling water. When wilted, drain and rinse with cold water. Then squeeze the spinach in your fist until all the water is extracted. Finely chop and combine the spinach with the eggs until well blended. Add the spinach-egg mixture to the flour as directed.

Tomato Pasta: For each egg, add 1 tablespoon of tomato paste. Combine the tomato paste with the eggs until well blended. Add the tomato-egg mixture to the flour as directed.

Cooking Homemade Pasta

Very thinly rolled homemade pasta cooks in less than 1 minute. All the rules for cooking pasta found on pages 10–11 apply, *except the sauce must be ready before the pasta is added to the boiling water.*

ith its sparkling flavors and incredible versatility, it's no wonder that pesto, the traditional Italian seasoning paste of basil, olive oil, and pine nuts, is so popular. For this recipe we added nontraditional herbs of cilantro and mint as well as chile and fresh ginger for spice. Once the pasta is drained, the pesto sauce is cooked in some of the reserved water used to boil the pasta in order to mellow the sharp raw garlic taste and to create a creamy pesto liquid that more evenly coats the pasta.

Fusilli with New World Pesto

Serves 4 as a side dish

INGREDIENTS

¾ cup pine nuts

1-inch-long piece of ginger, thinly
 sliced

3 cloves garlic

1 cup basil leaves

½ cup mint leaves

½ cup cilantro sprigs

¼ cup extra virgin olive oil

½ teaspoon salt

1 teaspoon Asian chile sauce

½ cup heavy cream

2 ounces Reggiano Parmesan cheese

8 ounces dried short fusilli, penne, or
 your favorite pasta

ADVANCE PREPARATION

Preheat oven to 325°. Place the pine nuts on a baking sheet and toast in the oven until golden, about 8 minutes. To make the pesto sauce, mince the ginger and garlic finely in a food processor. Then add the basil, mint, and cilantro and finely mince. Add half the nuts and mince finely. With the motor on, add the olive oil in a thin drizzle. Add the salt and chile sauce; process for 5 seconds. Transfer the pesto to a container, and press a layer of plastic wrap across its surface, then refrigerate. *All advance preparation steps may be completed up to 8 hours before you begin the final cooking steps.*

FINAL COOKING STEPS

Set aside the cream. Grate the cheese, about ½ cup. Bring 4 quarts of water to a rapid boil. Lightly salt the water, then cook the pasta according to the instructions on the package. When the pasta loses its raw texture but is still slightly firm, remove from the heat and drain the pasta.

Return the empty pasta pot to the stove over high heat. Add ½ cup of the pesto sauce, the cream, and the pasta. Stir and toss until evenly combined and well heated. Taste and adjust the seasonings. Add more pesto for a more pronounced flavor, more cream or water for a creamier texture, or more salt. Transfer the pasta to a heated platter or 4 heated dinner plates. Sprinkle on the cheese and remaining pine nuts. Serve at once.

SUGGESTED ACCOMPANIMENTS

Broiled snapper, a tomato salad with feta cheese, and a chocolate cake with walnuts

*W*e love complex-tasting sauces that take only minutes to prepare. For example, here a large amount of cilantro is combined with other seasonings in a blender and then lique-fied. During cooking, cream and the water from steaming the clams are added so that the sauce acquires a wonderful rich seafood taste. It's important to use steamer clams, which open after about a minute of steaming and are very tender. The larger cherrystone and littleneck clams will be tough, and canned clams will ruin the dish.

Pasta with Cilantro Cream Seafood Sauce

Serves 4 as the main entrée

INGREDIENTS

40 steamer clams, about 2 pounds

1 pound raw medium shrimp

8 ounces dried rotelle, fettucine, or your
 favorite pasta

3 tablespoons extra virgin olive oil

2 ounces pecorino or Reggiano
 Parmesan cheese

SAUCE

1 small bunch cilantro, large stems
 removed (about 1 cup)

½ cup basil leaves

2 tablespoons finely minced ginger

2 cloves garlic, finely minced

⅔ cup chicken stock

¼ cup dry sherry

1 tablespoon cornstarch

1 teaspoon Asian chile sauce

½ teaspoon salt

⅓ cup whipping cream

ADVANCE PREPARATION

Scrub the clams and refrigerate. Shell, devein, and split the shrimp nearly in half lengthwise. In separate containers, set aside the pasta, oil, and cheese.

To make the sauce, place all the sauce ingredients except the cream in an electric blender and blend at highest speed until completely liquefied. Transfer to a container, stir in the cream, and refrigerate. *All advanced preparation steps may be completed up to 8 hours before you begin the final cooking steps.*

FINAL COOKING STEPS

Grate the cheese, about ½ cup. Bring 4 quarts of water to a rapid boil. Lightly salt the water, then cook the pasta according to the instructions on the package. When the pasta loses its raw taste but is still slightly firm, remove from the heat and drain.

Meanwhile, place a small colander lined with cheesecloth in a bowl. Place a 12- or 14-inch sauté pan over high heat. Add ¼ inch of water. When the water comes to a rapid boil, add the clams, cover, and steam until all the clams open, about 1 to 2 minutes. Immediately tip the clams into the colander lined with cheesecloth. Then add ¾ cup of the clam-steaming water to the cilantro sauce.

Return the empty sauté pan to high heat. Add the olive oil. When the oil becomes hot, add the shrimp. Stir and toss until the shrimp turn white. Add the cilantro sauce. When the cilantro sauce comes to a boil and thickens slightly, add the clams (but not the remaining liquid in the bowl) and combine evenly with the sauce.

Place the pasta on a heated platter or 4 heated dinner plates. Spoon the seafood and sauce on top of the pasta. Sprinkle with cheese and serve at once.

SUGGESTED ACCOMPANIMENTS

A green bean and walnut salad and a ginger-praline mousse

*R*ich-tasting sauces never prove alluring unless the richness is juxtaposed with other flavors that provide dramatic contrasts. So in this recipe, the slight saltiness of the prosciutto brings out the flavors of the other ingredients, freshly chopped basil provides high notes, and the toasted walnuts lend a crunchy texture and slight bitterness long appreciated as a classic combination with Gorgonzola cheese.

Pasta with Gorgonzola Sauce

Serves 4 as a side dish

INGREDIENTS

⅓ cup extra virgin olive oil

5 cloves garlic, finely minced

2 ounces prosciutto

½ cup walnut pieces

1 red bell pepper

½ cup loosely packed basil leaves

8 ounces Gorgonzola or any blue cheese

8 ounces dried penne, fettucine, or your favorite pasta

½ teaspoon salt

¼ teaspoon crushed red pepper flakes

1 whole nutmeg

1 to 2 Thai bird chiles, for garnish (optional)

ADVANCE PREPARATION

Preheat the oven to 325° (for toasting the walnuts). Combine the oil and garlic. Cut the prosciutto into 1-inch-long shreds. Toast the nuts in the preheated oven until they become dark golden, about 15 minutes, then set aside. Stem and chop the pepper. Set aside the basil leaves. Crumble the Gorgonzola and refrigerate. Set aside the pasta. *All advance preparation steps may be completed up to 8 hours before you begin the final cooking steps.*

FINAL COOKING STEPS

Sliver the basil leaves. Bring 4 quarts of water to a rapid boil. Lightly salt the water, then cook the pasta according to the instructions on the package. When the pasta loses its raw texture but is still slightly firm, set aside 1 cup of the pasta water, then remove from the heat and drain.

Return the empty pasta pot to the stove over high heat. Add the olive oil and garlic. Sauté until the garlic begins to sizzle but has not browned. Return the pasta to the pot and add the prosciutto, walnuts, pepper, three-fourths of the cheese, basil, salt, pepper flakes, and the 1 cup of pasta water. Stir and toss until evenly combined and well heated. Taste and adjust the seasonings, especially for salt. Transfer the pasta to a heated platter or 4 heated dinner plates. Sprinkle on the remaining cheese, grate a little nutmeg over the pasta, and garnish with the chiles. Serve at once.

SUGGESTED ACCOMPANIMENTS

Barbecued beef tenderloin with juniper berries and lemon tarts

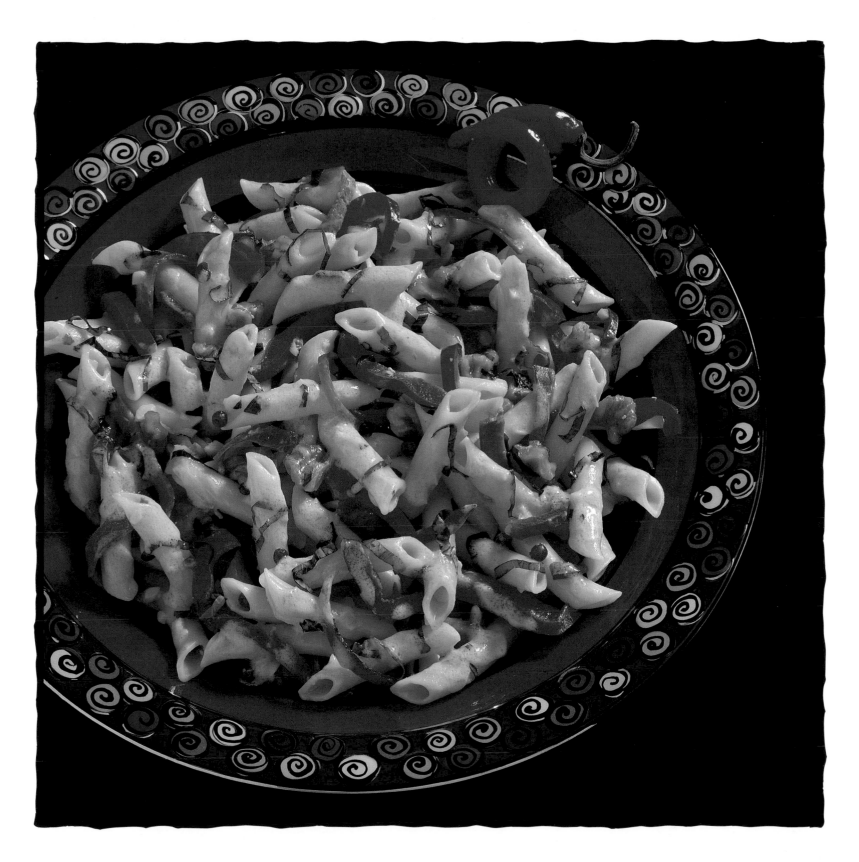

This is one of the most delicious, easiest, and richest-tasting pasta recipes in the book. Fresh shiitake mushrooms are sautéed briefly, and then boiled in a sesame-orange zest cream sauce until the sauce thickens into a glaze. On days when you are not in a pasta mood, spoon this sauce over thick slices of veal meatloaf or across pieces of barbecued chicken, or place the sauce on warm dinner plates and top with double-thick, roasted pork chops.

Pasta with Shiitake Cream Sauce

Serves 4 as a side dish

INGREDIENTS

¼ cup olive oil

1 tablespoon very finely minced ginger

½ pound shiitake mushrooms

1 carrot

2 whole green onions

8 ounces dried fettucine, tagliatelle, or your favorite pasta

2 ounces pecorino or Reggiano Parmesan cheese

1 bunch chives

SAUCE

1 cup heavy cream

½ cup white wine or dry vermouth

2 tablespoons thin soy sauce

1 tablespoon dark sesame oil

½ teaspoon finely minced orange zest

½ teaspoon Asian chile sauce

ADVANCE PREPARATION

In a small bowl, combine the oil and ginger. Discard the mushroom stems, cut mushroom caps in ¼-inch-wide strips, then refrigerate. Cut the carrot on a very sharp diagonal into ⅛-inch-wide slices, then overlap the slices and cut into matchstick-shaped pieces about ¼ inch thick. Shred the green onions, then combine with the carrot and refrigerate. Set aside the pasta, cheese, and chives.

In a bowl, combine all sauce ingredients, then refrigerate. *All advance preparation steps may be completed up to 8 hours before you begin the final cooking steps.*

FINAL COOKING STEPS

Grate the cheese, about ½ cup. Mince the chives. Bring 4 quarts of water to a rapid boil. Lightly salt the water, then cook the pasta according to the instructions on the package. When the pasta loses its raw texture but is still slightly firm, remove from the heat and drain.

Meanwhile, place a 12- or 14-inch sauté pan over high heat. When hot, add the oil-ginger mixture, and sauté until the ginger begins to sizzle but has not browned. Add the mushrooms, sauté for 15 seconds, then add the sauce. Bring the sauce to a rapid boil, and boil until it turns light brown and thickens enough to lightly coat the spoon, about 4 minutes.

Stir in the carrots and green onions. Add the pasta. Stir and toss until evenly combined and well heated. Taste and adjust the seasonings, especially for salt. Transfer the pasta to a heated platter or 4 heated dinner plates. Sprinkle with cheese and chives. Serve at once.

SUGGESTED ACCOMPANIMENTS

Pork chops with a Cajun-style butter and a hot peach crumble

*T*o make perfect salmon ravioli, use the very freshest, bright pink salmon, find the thinnest gyoza or wonton wrappers, and poach the dumplings only until they float to the surface of the boiling water. Gently transferred to hot dinner plates and topped with this rich tomato cream sauce, these ravioli are a visual and taste triumph.

Salmon Ravioli with Tomato Cream Sauce

Serves 4 as the main entrée or 6 to 10 as an appetizer

INGREDIENTS

2 whole green onions, minced

¾ pound fresh salmon fillet, skinned and minced

1 clove garlic, finely minced

2 eggs

1 tablespoon oyster sauce

60 thin round gyoza or wonton wrappers

¼ cup cornstarch

2 ounces pecorino or Reggiano Parmesan cheese

½ cup parsley sprigs

SAUCE

2 tablespoons extra virgin olive oil

2 cloves garlic, very finely minced

2 vine-ripened tomatoes, seeded and chopped

½ cup whipping cream

¼ cup dry vermouth

1 tablespoon oyster sauce

½ teaspoon Asian chile sauce

2 tablespoons chopped fresh oregano leaves

1 tablespoon fresh thyme leaves

ADVANCE PREPARATION

To make the filling, combine the green onions, salmon, garlic, 1 egg, and oyster sauce, and mix thoroughly. Place 2 teaspoons of the filling in the center of a wrapper. (If using square wonton wrappers, trim them into circles.) Beat the remaining egg, then moisten the wrapper edge with a little beaten egg. Place another wrapper on top and firmly press together to tightly seal. Repeat with the remaining ravioli. Line a baking sheet with parchment paper, dust the paper heavily with cornstarch, place the ravioli in a single layer on the baking sheet, and refrigerate uncovered. In separate containers, set aside the cheese and parsley.

Combine the olive oil and garlic. In a bowl, combine the remaining sauce ingredients, stir well, and then refrigerate. *All advance preparation steps may be completed up to 8 hours before you begin the final cooking steps.*

FINAL COOKING STEPS

Grate the cheese, about ½ cup. Mince the parsley. Place a 12-inch sauté pan over high heat. Add the oil-garlic mixture. Sauté until the garlic sizzles but has not browned. Add the sauce and bring to a rapid boil. Cook until the sauce begins to thicken, about 3 minutes. Taste and adjust the seasonings, especially for salt. Keep warm.

Bring 4 quarts of water to a rapid boil. Lightly salt the water, then stir in the ravioli. When the ravioli rise to the surface, about 45 seconds, gently transfer them to a colander to drain briefly. Transfer the ravioli to a heated platter or 4 heated dinner plates. Spoon the sauce over the ravioli, sprinkle with cheese and parsley, and serve at once.

SUGGESTED ACCOMPANIMENTS

A Caesar salad with chile croutons and a strawberry-rhubarb crisp

Hot Pasta through the Ages

The origins of pasta are a mystery. Pasta may have begun as a floury soup that overcooked into a solid mass. Then it was probably dried, cut into strips, and added to soups or fried in oil. We do know, however, that Arab traders introduced flour-milling technology westward to ancient Greece and eastward across the great inner Asian steppes to China. By the Han Dynasty (221 BC – AD 220), noodles were common in China, as evidenced by a flour-kneading scene found in the Han tombs. The Western Chin writer Shu Hsi (late third and early fourth centuries AD) described the art of flour kneading and how noodles could be cooked with meats (especially mutton and pork) and seasonings (including ginger and scallions).

Across the globe, Etruscans decorated their tombs with scenes of domestic life, including implements for making pasta dough. The Roman Apicius dedicated a chapter to pasta dough in his third-century AD book *De Re Coquinaria*, including recipes for fried strips served with pepper and honey. Yet there is no Roman description of pasta dough that is rolled into thin sheets, cut into strips, and boiled in water.

European Pasta, as we know it, is first clearly documented in Italy in the thirteenth century just before Marco Polo returned from China. During the next century, pasta shapes proliferated across Italy. Stuffed pasta such as tortellini were well known by the thirteenth century. By the fourteenth and fifteenth centuries, pasta was still too expensive to be an everyday staple in the Italian diet. One major change was the introduction of tomatoes from Mexico and Peru in the sixteenth century. By the seventeenth century, the Italians, overcoming their initial suspicions about that poisonous-looking fruit, embraced tomatoes. Tomatoes gave rise to a wide variety of sauces and led to the demise of the ancient preference for flavoring pastas with honey, sugar, and spices such as cinnamon.

Naples became the European capital of pasta from the sixteenth century to the time of Mussolini. Hot winds from Mount Vesuvius provided the perfect temperature; pasta neither took so long to dry that it began to mold nor dried so quickly that it became brittle. Grain ships filled the harbor. Pasta hung in the streets and from balconies and roofs. Charcoal fires surrounded by wooden stalls lined the streets; pots of boiling, salted water bubbled with macaroni, and mounds of grated cheese waited as the final seasoning. The number of shops selling pasta in Naples increased from 60 in 1700 to 280 by 1785. Pasta dough was kneaded by foot in long wooden troughs for a day. Then the dough was extruded through pierced dies under great pressure by use of a large screw press operated by men or horses. Eighteenth-century prints show Neapolitan children eating pasta by lowering it into their mouths. This had been the common way of eating it until Gennaro

Spadaccini, a chamberlain at the fifteenth-century Bourbon court in Naples, invented the modern four-pronged fork to spare visiting foreigners the embarrassment of eating pasta with their hands.

In the twelfth century, the word for pasta in Italy was *macaronis*. The first mention of the word in English was in one of Ben Jonson's manuscripts written in 1599. In 1673, the English traveler J. Ray wrote, "*Paste* was made into strings like pack-thread or thongs of whit-leather (which if greater they call *Macaroni*, if lesser *Vermicelli*) they cut in pieces and put in their pots as we do oat-meal." In seventeenth-century England, the word "macaroni" came to refer to a class of men who traveled to Italy and affected the tastes and fashions prevalent in Continental society. In 1770 the *Oxford Magazine* said, "There is indeed a kind of animal, neither male nor female, a thing of the neuter gender, lately started up amongst us. It is called a Macaroni. It talks without meaning, it smiles without pleasantry, it eats without appetite, it rides without exercise, it wenches without passion." By the mid-eighteenth century, "macaroni" referred to a foppish hairstyle as well as to the dandy wearing it. The song "Yankee Doodle" was used by the British to ridicule the American colonists, who adopted it in self-defense.

The British introduced pasta to colonial America, though the British contribution seems limited to one dish, macaroni and cheese. Congressman Manasseh Cutler described eating the dish at a dinner given by Thomas Jefferson at the White House: "It appeared to be a rich crust filled with strillions of onions, or shallots, which I took them to be, tasted very strong, and not agreeable. Mr. Lewis (Jefferson's secretary) told me there were none in it; it was made of flour and butter, with a particularly strong liquor mixed with it."

America's passion for pasta evolved gradually, and today it has emerged as one of our most popular foods. Macaroni and cheese was commonplace in early America, but the interest in pasta did not extend much further until three million Italian immigrants began to arrive, beginning at the time of the Gold Rush in 1849 and building to a crescendo between 1900 and 1914. They brought their cooking traditions and products, opened restaurants, and established Italian markets in virtually every major community in the United States. By the end of 1920, Italian restaurants had become the most popular ethnic restaurants in American cities, a lead they maintain nationwide today. In 1994, America surpassed Italy for the first time as the world's largest pasta consumer, consuming a staggering 3.94 billion pounds of pasta. Markets that sold only spaghetti, linguine, macaroni, and lasagna just two decades ago, now offer an ever-increasing variety of commercial dry pasta shapes, colors, and flavors. Today, American cooks agree that pasta is one of the world's great gastronomic pleasures whether we are cooking for quick weeknight dinners or for weekend festivities. The Age of Pasta has arrived.

The wonderful richness of this cream sauce is fantastic matched with the background flavors of chiles, fresh tarragon, and garlic. The sauce is reduced at a fast boil so the flavors are even more pronounced. Vary the recipe by substituting cilantro or basil in place of the tarragon, or replace the cream with chicken broth and then stir into the pasta dish 1/4 cup of crème fraîche during the final minute of cooking.

Pasta with Tarragon Cream

Serves 4 as a side dish

INGREDIENTS

1 large carrot

2 zucchini

8 ounces dried linguine, fettucine, or your favorite pasta

2 ounces pecorino or Reggiano Parmesan cheese

1 bunch chives

SAUCE

3 tablespoons unsalted butter

4 cloves garlic, finely minced

1 tablespoon very finely minced ginger

2 tablespoons chopped tarragon leaves

¾ cup white wine or chicken broth

½ cup heavy cream

¼ cup dry sherry

½ teaspoon Asian chile sauce

½ teaspoon salt

2 teaspoons cornstarch

ADVANCE PREPARATION

Cut the carrot on a very sharp diagonal into ⅛-inch-wide slices, then overlap the slices and cut into matchstick-shaped pieces about ¼ inch wide. Cut the zucchini in the same manner, then combine the vegetables and refrigerate. Set aside the pasta, cheese, and chives.

In a small bowl, combine the butter, garlic, and ginger, then refrigerate. In a bowl, combine the remaining sauce ingredients, then refrigerate. *All advance preparation steps may be completed up to 8 hours before you begin the final cooking steps.*

FINAL COOKING STEPS

Grate the cheese, about ½ cup. Mince the chives. Bring 4 quarts of water to a rapid boil. Lightly salt the water, then cook the pasta according to the instructions on the package. When the pasta loses its raw texture but is still slightly firm, remove from the heat and drain.

Return the empty pasta pot to the stove over high heat. Add the butter mixture. Sauté until the garlic and ginger begin to sizzle but have not browned. Add the vegetables and sauté until they brighten, about 1 minute. Add the cream sauce. Bring the cream sauce to a rapid boil and cook until it thickens, about 2 minutes.

Add the pasta. Stir and toss until evenly combined and well heated. Taste and adjust the seasonings, especially for salt. Transfer the pasta to a heated platter or 4 heated dinner plates. Sprinkle with cheese and chives. Serve at once.

SUGGESTED ACCOMPANIMENTS

Roast pork loin stuffed with dried fruit, a salad of baby greens, and raspberry sorbet with chocolate cookies

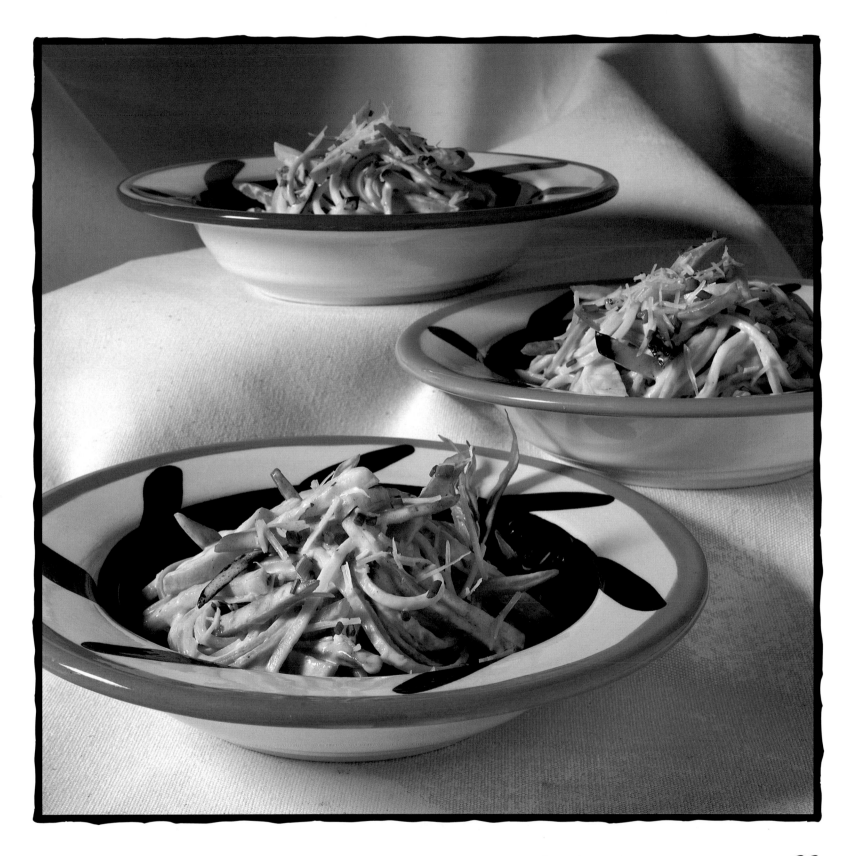

Although this garlic-roasted pepper sauce is used on tortellini, it is very good tossed with 8 ounces of dry commercial pasta that is boiled and drained. For another variation, substitute 4 vine-ripened tomatoes for the red pepper. Split the tomatoes in half, brush the exposed flesh with olive oil, and broil until lightly browned. Purée the tomatoes and add to the remaining sauce ingredients.

Tortellini with Garlic – Roasted Pepper Sauce

INGREDIENTS

1 pound ground veal

¼ cup pesto sauce

1 egg

½ teaspoon salt

40 thin round gyoza or wonton wrappers

¼ cup cornstarch

¼ cup pine nuts

½ cup parsley sprigs

2 teaspoons lemon zest, for garnish

½ cup chopped red bell pepper
 (optional)

SAUCE

2 tablespoons extra virgin olive oil

3 cloves garlic, finely minced

1 (7-ounce) jar roasted red peppers

¾ cup heavy cream

2 teaspoons finely minced lemon zest

½ teaspoon salt

¼ teaspoon freshly ground black pepper

ADVANCE PREPARATION

Preheat the oven to 325° (for toasting the pine nuts).

In a bowl, combine the veal, pesto sauce, egg, and salt, then mix thoroughly. Place 2 teaspoons of the filling in the center of a wrapper. (If using square wontons, trim the wontons into circles.) Moisten the edge with a little water. Fold the wrapper over and pinch the edges to seal. Now moisten one end with water. Bring the two ends together and pinch firmly to seal. Repeat with the remaining tortellini. Line a baking sheet with parchment paper, dust the paper heavily with cornstarch, place the tortellini in a single layer on the baking sheet, and refrigerate uncovered.

Toast the pine nuts in the preheated oven until golden, about 8 minutes. Set aside the parsley, lemon zest garnish, and chopped bell pepper. Combine the oil and garlic, then set aside. Place all the remaining sauce ingredients in an electric blender, and blend until liquefied; then refrigerate. *All advance preparation steps may be completed up to 8 hours before you begin the final cooking steps.*

FINAL COOKING STEPS

Mince the parsley. Bring 4 quarts of water to a rapid boil. Lightly salt the water, then stir in the tortellini. As soon as the tortellini rise to the surface, about 1 minute, gently transfer them to a colander to drain briefly. Then transfer the tortellini to a heated platter or 4 heated dinner plates.

Meanwhile, place a 12-inch sauté pan over high heat. When hot, add the oil and garlic. Sauté until the garlic begins to sizzle but has not browned. Add the sauce. Bring the sauce to a boil, and simmer 30 seconds. Taste and adjust the seasonings, especially for salt and pepper. Spoon the sauce over the tortellini. Or alternatively, place the sauce on the plates and set the tortellini on top. Sprinkle with nuts, parsley, lemon zest, and chopped bell pepper. Serve at once.

SUGGESTED ACCOMPANIMENTS

An endive and cracked black pepper salad and an apricot tart with a praline crust

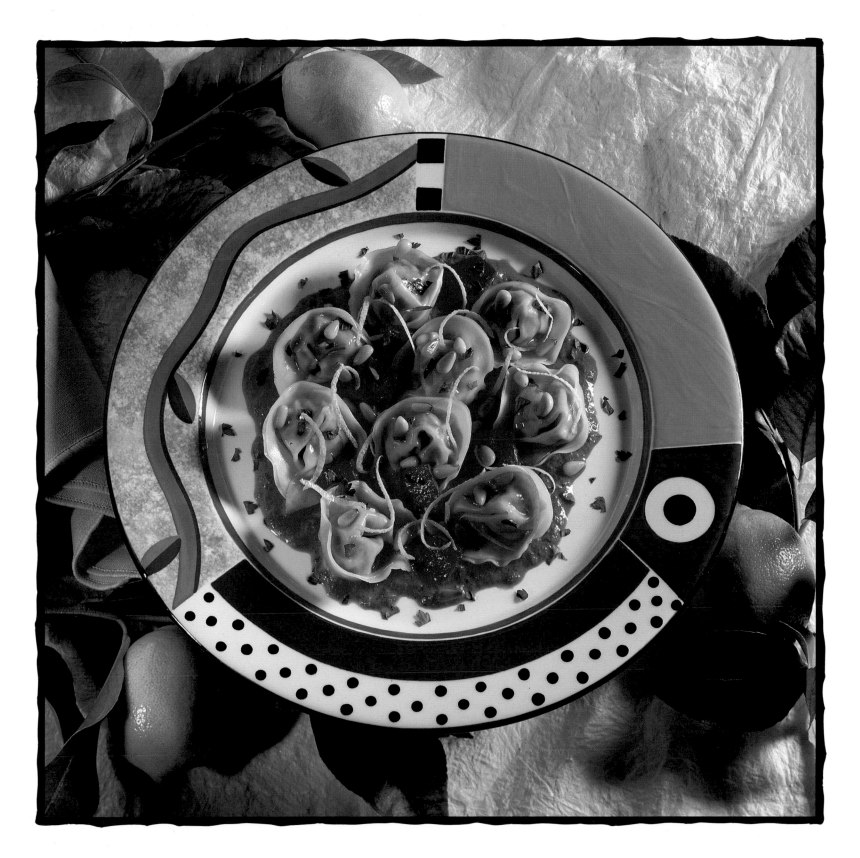

References to macaroni with cheese date to the eighth century AD, when the Saracen Arabs introduced the combination to Sicilian cooking. In eighteenth-century America, the recipe was already commonplace in cookbooks, menus, and at White House dinners given by Thomas Jefferson. While some versions use a béchamel sauce as the base for the eggs and cheese, we think this simpler combination of milk, beaten eggs, and grated cheese is just as good. Although the following recipe uses five cheeses, the dish tastes delicious if you use just one or any combination of these cheeses.

Macaroni with Five Cheeses

Serves 4 as the main entrée

INGREDIENTS

8 ounces dried elbow macaroni, penne, or your favorite pasta

3 eggs, beaten

1⅓ cups milk

½ teaspoon freshly grated nutmeg

¼ to ½ teaspoon salt

¼ teaspoon freshly ground white pepper

6 ounces sharp Cheddar cheese, grated

2 ounces dry Monterey jack cheese, grated (optional)

2 ounces Gruyère cheese, shredded

2 ounces Reggiano Parmesan cheese grated

2 ounces goat cheese, crumbled

1 ounce prosciutto, chopped

¼ cup chopped tarragon or basil leaves

ADVANCE PREPARATION

Butter the bottom and sides of a 13 x 9-inch baking pan. Bring 4 quarts of water to a rapid boil. Lightly salt the water, then cook the pasta according to the instructions on the package. When the pasta loses its raw texture but is still slightly firm, remove from the heat, drain, rinse under cold water, then drain again. Transfer the pasta to a large bowl.

In a small bowl, combine eggs, milk, nutmeg, salt, and white pepper. Beat with a whisk until well blended, then stir the liquid into the pasta. Set aside 2 ounces of the Cheddar, then add all the other ingredients to the pasta and gently stir until evenly combined.

Fill the baking pan with the pasta. Sprinkle on the remaining Cheddar. If the dish is made more than 1 hour before serving, refrigerate. *All advance preparation steps may be completed up to 8 hours before you begin the final cooking steps.*

FINAL COOKING STEPS

Preheat the oven to 350°. Place the baking pan in the preheated oven about 4 inches below the broiler, and bake uncovered until the pasta is thoroughly reheated and the cheese sauce is bubbling, about 30 minutes. Turn the oven setting to "broil" and cook until the top is golden, about 5 minutes. Serve at once.

SUGGESTED ACCOMPANIMENTS

A tomato and avocado salad with balsamic herb dressing and a peach cobbler with Grand Marnier butter sauce

*C*ream, lemon, herbs, and Parmesan cheese—this is a classic pasta from the old country with a twist. We have cooked this dish with many variations. In place of the asparagus, try substituting 2 cups of shelled peas or ¼ cup capers. Replace the recommended herbs with ½ cup chopped cilantro, or 1 cup chopped flat-leaf parsley. Intensify the citrus flavor by adding 1 teaspoon minced orange zest to the sauce. And if you want it "hot," increase the amount of fresh chiles, use a chile sauce, or garnish with crushed red pepper flakes.

Pasta with Spicy Lemon Cream Sauce

Serves 4 as a side dish

INGREDIENTS

1 bunch thin asparagus

8 ounces dried linguine, fettucine, or
 your favorite pasta

2 ounces pecorino or Reggiano
 Parmesan cheese

⅓ cup basil leaves

SAUCE

3 tablespoons extra virgin olive oil

4 cloves garlic, finely minced

1 cup heavy cream

1½ tablespoons finely minced lemon
 zest

¼ cup freshly squeezed lemon juice

1 teaspoon Asian chile sauce

½ teaspoon salt

ADVANCE PREPARATION

Discard tough asparagus ends, then cut asparagus on a sharp diagonal into 1-inch lengths; refrigerate. Set aside separately the pasta, cheese, and basil.

In a small container, combine the oil and garlic. In a small bowl, combine all the remaining sauce ingredients, and refrigerate. (The sauce will appear curdled.) *All advance preparation steps may be completed up to 8 hours before you begin the final cooking steps.*

FINAL COOKING STEPS

Grate the cheese, about ½ cup. Chop the basil. Bring 4 quarts of water to a rapid boil. Lightly salt the water, then cook the pasta according to the instructions on the package. When the pasta loses its raw texture but is still slightly firm, remove from the heat and drain.

Meanwhile, in a 12- or 14-inch sauté pan placed over medium-high heat, add the oil and garlic. Sauté until the garlic begins to sizzle but has not browned. Add the asparagus. Sauté until the asparagus brightens, then add the cream mixture. Bring to a rapid boil. Add the pasta and basil. Stir and toss until evenly combined and well heated. Taste and adjust the seasonings, especially for salt. Transfer the pasta to a heated platter or 4 heated dinner plates. Sprinkle with cheese and serve at once.

SUGGESTED ACCOMPANIMENTS

Roast chicken with a cognac glaze, an arugula salad, and strawberries with cream

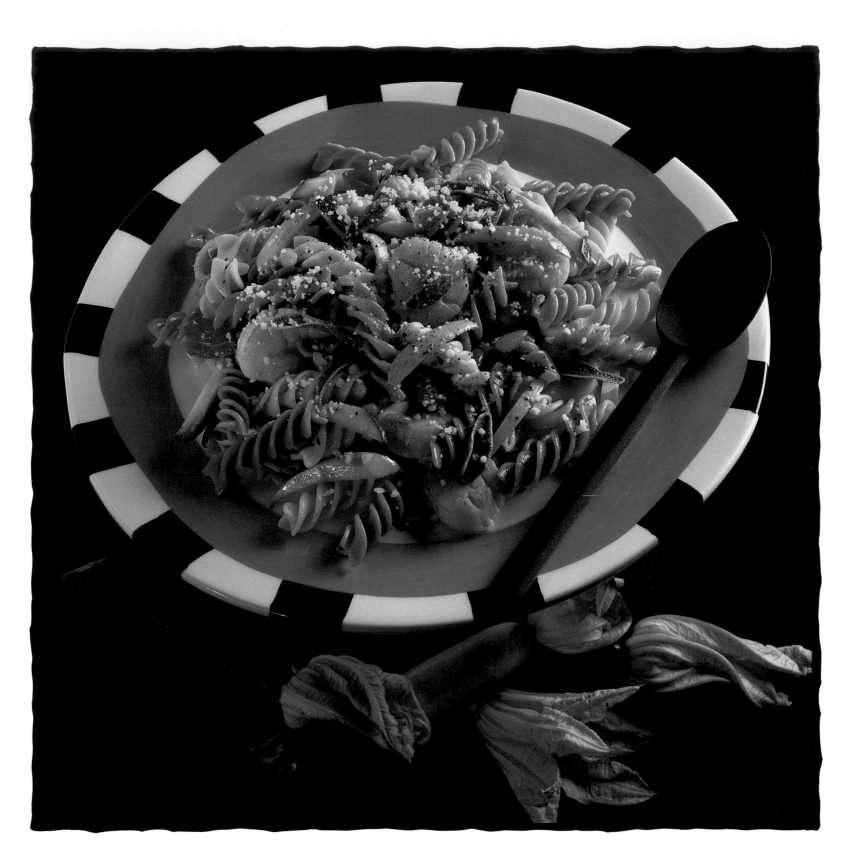

B rowned butter adds an incredible nutty taste to pasta. Matched with toasted pine nuts, prosciutto, and Parmesan cheese, these flavors create perfect harmony. It's important to brown the butter properly. Preheat the pan over medium-high heat until it becomes moderately hot. Add the butter and roll it quickly around the surface of the pan. Watch the butter as its color changes. If the butter does not turn a golden brown, the pasta will lack the necessary flavor. And if the butter becomes brown-black, discard it and begin again.

Browned Butter Pasta with Scallops

Serves 4 as the main entrée

INGREDIENTS

1½ pounds small fresh sea scallops or raw shrimp, shelled and deveined

2 zucchini

½ cup pine nuts

½ cup unsalted butter

5 cloves garlic, finely minced

2 ounces prosciutto

¼ cup loosely packed sage leaves

⅓ cup loosely packed basil leaves

8 ounces dried fusilli, radiatore, or your favorite pasta

3 ounces pecorino or Reggiano Parmesan cheese

¾ cup chicken stock

2 teaspoons cornstarch

½ teaspoon salt

Freshly ground black pepper

ADVANCE PREPARATION

Preheat the oven to 325° (for toasting the pine nuts). Drain the scallops of all moisture, and refrigerate. Cut the zucchini on a very sharp diagonal into ⅛-inch-wide slices. Overlap the slices and cut into matchstick pieces about ¼ inch wide; refrigerate. Toast the pine nuts in the preheated oven until golden, about 8 minutes; then set aside. Combine the butter and garlic. Cut the prosciutto into shreds ⅛ inch wide and about 1 inch long, then refrigerate. In separate containers, set aside the herbs, pasta, and cheese. In a small container, combine the chicken stock, cornstarch, and salt. *All advance preparation steps may be completed up to 8 hours before you begin the final cooking steps.*

FINAL COOKING STEPS

Coarsely chop the herbs. Grate the cheese, about ¾ cup. Bring 4 quarts of water to a rapid boil. Lightly salt the water, then cook the pasta according to the instructions on the package. When the pasta loses its raw texture but is still slightly firm, remove from the heat and drain.

Meanwhile, place a 12- or 14-inch sauté pan over high heat. When hot, add the butter and garlic. Melt the butter, and cook until the garlic sizzles and the butter becomes light golden. Add the scallops and cook over high heat until they lose their raw outside color, about 1 minute. Add the zucchini and cook until they brighten, about 30 seconds.

Add the pasta, nuts, prosciutto, herbs, and chicken stock mixture. Stir and toss until evenly combined and well heated. Stir in half the cheese. Taste and adjust the seasonings, especially for salt and black pepper. Transfer the pasta to a heated platter or 4 heated dinner plates. Sprinkle on the remaining cheese, and serve at once.

SUGGESTED ACCOMPANIMENTS

A cucumber, tomato, and anise root salad and a blackberry tart with chocolate candies

Glossary

Andouille: This mildly spicy, Cajun smoked pork sausage is available at most supermarkets. Substitute: Spicy Italian or Mexican sausage.

Cheese, Parmesan, Pecorino, and Asiago: Use these three cheeses interchangeably. Because the imported Italian cheeses have a far superior taste to the same type of cheese made in this country, make an extra effort to locate these Italian cheeses at up-scale supermarkets and cheese shops. As long as the cheese has not been grated, it will last at least 1 month wrapped airtight and refrigerated.

Chicken Stock: When homemade chicken stock is unavailable, all the recipes work well using canned low-salt stock. Best brand: Swanson Low-Salt Chicken Stock.

Chiles, Ancho: These reddish purple dried chiles have a fruity, mildly spicy taste that makes them a particularly great addition to tomato sauces and homemade chili. They are sold in all Mexican markets, and American supermarkets that have a wide selection of dry chiles. Substitute: Dried mulatto or pasilla chiles.

Chiles, Fresh: The smaller the chile, the spicier its taste. Over 80 percent of the heat is concentrated in the ribs and seeds. Because it is a tedious operation to remove the seeds from jalapeño and serrano chiles, we always mince the chiles along with their seeds. Substitute: Your favorite bottled chile sauce.

Chile Sauce, Asian, Caribbean, or Louisianan: This is a general term for the countless varieties of chile and hot pepper sauces from around the world. Use your own favorite chile sauce and vary the amount depending on personal preference. Most of the recipes specify Asian chile sauce. Best brand: Rooster brand Delicious Hot Chili Garlic Sauce, sold in 8-ounce clear plastic jars with a green cap (refrigerate after opening). Substitute: One or more fresh jalapeño or serrano chiles.

Chipotle Chiles in Adobo: Smoked, dried jalapeños that are stewed in a tomato-vinegar-garlic sauce, chipotle chiles in adobo are available in 4-ounce cans at all Mexican markets and many supermarkets. To use, purée the chiles with the adobo in a blender or an electric mini-chopper. It is unnecessary to remove the seeds. Substitute: None.

Citrus Juice and Zest: Freshly squeezed citrus juice has a sparkling fresh taste completely absent from all store-bought juices. Because its flavor deteriorates quickly, always squeeze citrus juice within hours of use and keep it covered and refrigerated. When a recipe calls for finely minced zest, remove the colored skin of the citrus using a simple tool called a zester, and then finely mince the zest.

Coconut Milk: Coconut milk adds flavor and body to sauces and is available canned in most supermarkets. Always purchase a Thai brand whose ingredients are just coconut and water. Never buy the lowfat coconut milks because they have a bad taste. Stir the coconut milk before using. Best brand: Chaokoh brand from Thailand. Once opened, store coconut milk covered in the refrigerator for up to 1 week. Substitute: Half-and-half or chicken stock. If substituting chicken stock, you may want to stir a little cornstarch-water mixture into the sauce just before serving in order to add more body.

Cooking Oil: Use any flavorless oil with a high smoking temperature, such as peanut oil, canola oil, safflower oil, or corn oil.

Crème Fraîche: This is a sour-tasting cream with nutty undertones and is available in the sour cream section of most supermarkets, or make your own following the instructions on page 83.

Fish Sauce, Thai: Fish sauce, made from fermenting fish in brine, is used in Southeast Asian cooking to add flavor in much the same way as the Chinese use soy sauce. Purchase Thai fish sauce, which has the lowest salt content. Best brands: Three Crab brand, Phu Quoc Flying Lion brand, or Tiparos brand Fish Sauce. Substitute: Thin soy sauce, although the flavor is quite different.

Ginger, Fresh: These pungent and spicy "roots" grown in Hawaii are available in the produce section of all supermarkets. Buy firm ginger with a smooth skin. It is unnecessary to peel ginger unless the skin is wrinkled. Because the tough ginger fiber runs lengthwise along the root, always cut the ginger crosswise in paper-thin slices, then very finely mince in an electric mini-chopper. Good-quality fresh ginger is so inexpensive and easily available that it is unnecessary to take elaborate storage precautions. There is no substitute for fresh ginger.

Gyoza Wrappers: See *Wonton Wrappers.*

Hoisin Sauce: Hoisin sauce, a thick and sweet, spicy, dark condiment, is made with soybeans, chiles, garlic, ginger, and sugar. Once opened, it keeps indefinitely at room temperature. Best brand: Koon Chun Hoisin Sauce.

Olive Oil: Recipes specifying "extra virgin olive oil" benefit from this intensely flavored, green-tinted oil. Use "olive oil," or "light olive oil" when little or no olive oil taste is wanted in the dish.

Oyster Sauce: Also called "oyster flavored sauce," this sauce gives dishes a complex taste without a hint of its seafood origins. It keeps indefinitely in the refrigerator. There is no substitute. Although it is available at every supermarket, the following best brands are available mostly at Asian markets: Sa Cheng Oyster Flavored Sauce, Hop Sing Lung Oyster Sauce, and Lee Kum Kee Oyster Flavored Sauce, Premium brand.

Prosciutto: This is an air- and salt-cured Italian ham that is excellent when added in small amounts to flavor pasta dishes. If Italian prosciutto is not available, substitute a low-salt, flavorful American ham.

Rice Wine, Chinese, or Dry Sherry: Always use good-quality Chinese rice wine or an American or Spanish dry sherry. The best brands of rice wine are Pagoda brand Shao Xing Rice Wine, Pagoda brand Shao Hsing Hua Tiao Chiew, or use a moderately expensive dry sherry.

Sesame Oil, Dark: This is a nutty, dark golden brown oil, made from toasted crushed sesame seeds. Do not confuse dark sesame oil with the American-manufactured, clear-colored and tasteless sesame oil or Chinese black sesame oil, which has a strong unpleasant taste. Dark sesame oil will last for at least a year at room temperature and indefinitely in the refrigerator. Best brand: Kadoya Sesame Oil.

Soy Sauce, Thin: "Thin" or "light" soy sauce is a "watery," mildly salty liquid made from soybeans, roasted wheat, yeast, and salt. If you are concerned about sodium, reduce the quantity of soy sauce, rather than using the inferior-tasting, more expensive low-sodium brands. Best brands: Pearl River Bridge brand Golden Label Superior Soy Sauce, Koon Chun brand Thin Soy Sauce, or Kikkoman Regular Soy Sauce.

Tomatoes, Fresh, and Tomato Paste: All recipes using tomatoes specify "vine-ripened tomatoes." During the months when these are unavailable, substitute "hot-house tomatoes." To enhance the flavor of hot-house tomatoes, cut the tomatoes into 1/4-inch-thick slices, and broil on both sides until lightly golden. This intensifies their "tomato" flavor. Then cut and use as directed in the recipe. In addition, we often add 1 teaspoon of tomato paste. Best brand: Pagani, which is sold in 4 1/2-ounce tubes.

Vinegar, Balsamic: This black, Italian vinegar has a complex nutty, mildly sour, slightly sweet flavor. For recipes in this book, use a moderately priced balsamic vinegar ($5 for an 8-ounce bottle) available in most supermarkets.

Vinegar, Rice: The mild flavor of Japanese rice vinegar makes this a great addition to salads. Avoid "seasoned" or "gourmet" rice vinegar, which has sugar and MSG added.

Wonton Wrappers: Sold fresh or frozen by most supermarkets and all Asian markets, buy the thinnest wonton wrappers or round gyoza wrappers. They can be stored in the refrigerator for 1 week or frozen indefinitely.

Artists' Credits

We would especially like to thank Julie Sanders of Cyclamen Studio, Berkeley, CA, for her beautiful ceramic tableware appearing on pages 6–7, 15, 18, 39, 45, 65, 71, 80, and 90. Thanks to artist Julie Cline of Oakland, CA, whose handpainted ceramics appear on pages 30, 48, 78, and 93. Robin Spear, of Los Angeles, made the pasta bowls on pages 98, 99, and 109. Susan Eslick of San Francisco created the striking plates on pages 63 and 101. Kathy Erteman of New York City made the graphic ceramics on pages 1 and 41. Thanks also to ceramicist Aletha Soule of Sebastopol, CA, for the dishes and pasta bowls on pages 27, 75, and 85.

Tantau Gallery of St. Helena, CA, provided the Fioriware on page 23, the bowl by Kaj on page 35; and the "Backsplash" fish plate on page 53. Rasberry's Gallery, Yountville, CA, gave us the "hot" wine glasses by Ricky Charles Dodson on page 5. R.H. Basso and Co., St. Helena, CA, provided much of the iron ware for the photography. And the Culinary Institute of America at Greystone, St. Helena, CA, provided help with the necessary cookware. Thank you all.

Acknowledgments

Many friends helped bring this book into print and we are deeply appreciative for their support. Thank you, Ten Speed Press, particularly Phil Wood, publisher Kirsty Melville, editor Lorena Jones, and Jo Ann Deck. Our friend and book designer, Beverly Wilson, contributed her unique vision for the book. Sebastopol food stylist Carol Cole added her food artistry to several of the photos. Jack and Dolores Cakebread provided their winery kitchen for testing many of these recipes with a small group of cooking friends. All the recipes were developed using the superb Viking Gas Ranges and Commercial Aluminum Cookware. Seattle research librarian Linda Saunto provided the background information upon which the section "Pasta Through the Ages" was based. Friends Kim and George David, Bettylu and Lou Kessler, and Barbara and Bob Sandison worked with us on the section "Quick Pasta Recipes." Finally, the recipes were evaluated by the following home cooks who contributed many thoughtful insights: David Black, Ginny Bogart, Russ and Jan Bohne, Jo Bowen, Judy Burnstein, Bill and Lynda Casper, Tobey Cotsen, Kris Cox, Bert Crews, Kim and George David, Claire Dishman, Judith Dubrawski, Nora Feune De Colombi, Suzanne Figi, Sharie and Ron Goldfarb, Robert Gordon, Blanche and Sy Gottlieb, Joann Hecht, Donna Hodgens, Linda and Ron Johnson, Candy and Gil Katen, Bettylu and Lou Kessler, Jeannie Komsky, Susan Krueger, Jeremy Mann, Michele Nipper, Kris Robinson, Joe Rooks, Paul and Mary Jo Shane, Ellie Shulman, Betty Silbart, Phil Stafford, Amy and Douglas Stevens, Suzanne Vadnais, Hermia Woo, and Sue Zubik.

LIQUID MEASUREMENTS

Cups and Spoons	Liquid Ounces	Approximate Metric Term	Approximate Centiliters	Actual Milliliters
1 tsp	⅙ oz	1 tsp	½ cL	5 mL
1 Tb	½ oz	1 Tb	1 ½ cL	15 mL
¼ c; 4 Tb	2 oz	½ dL; 4 Tb	6 cL	59 mL
⅓ c; 5 Tb	2 ⅔ oz	¾ dL; 5 Tb	8 cL	79 mL
½ C	4 oz	1 dL	12 cL	119 mL
⅔ c	5 ⅓ oz	1 ½ dL	15 cL	157 mL
¾ c	6 oz	1 ¾ dL	18 cL	178 mL
1 c	8 oz	¼ L	24 cL	237 mL
1 ¼ c	10 oz	3 dL	30 cL	296 mL
1 ⅓ c	10 ⅔ oz	3 ¼ dL	33 cL	325 mL
1 ½ c	12 oz	3 ½ dL	35 cL	355 mL
1 ⅔ c	13 ⅓ oz	3 ¾ dL	39 cL	385 mL
1 ¾ c	14 oz	4 dL	41 cL	414 mL
2 c; 1 pt	16 oz	½ L	47 cL	473 mL
2 ½ c	20 oz	6 dL	60 cL	592 mL
3 c	24 oz	¾ L	70 cL	710 mL
3 ½ c	28 oz	⅘ L; 8 dL	83 cL	829 mL
4 c; 1 qt	32 oz	1 L	95 cL	946 mL
5 c	40 oz	1 ¼ L	113 cL	1134 mL
6 c; 1 ½ qt	48 oz	1 ½ L	142 cL	1420 mL
8 c; 2 qt	64 oz	2 L	190 cL	1893 mL
10 c; 2 ½ qt	80 oz	2 ½ L	235 cL	2366 mL
12 c; 3 qt	96 oz	2 ¾ L	284 cL	2839 mL
4 qt	128 oz	3 ¾ L	375 cL	3785 mL
5 qt	4 ¾ L			
6 qt	5 ½ L (or 6 L)			
8 qt	7 ½ (or 8 L)			

Conversion Charts

LENGTH

⅛ in = 3 mm
¼ in = 6 mm
⅓ in = 1 cm
½ in = 1.5 cm
¾ in = 2 cm
1 in = 2.5 cm
1 ½ in = 4 cm
2 in = 5 cm
2 ½ in = 6 cm
4 in = 10 cm
8 in = 2 cm
10 in = 25 cm

TEMPERATURES

275˚F = 140˚C
300˚F = 150˚C
325˚F = 170˚C
350˚F = 180˚C
375˚F = 190˚C
400˚F = 200˚C
450˚F = 230˚C
475˚F = 240˚C
500˚F = 250˚C

OTHER CONVERSIONS

Ounces to milliliters: multiply ounces by 29.57

Quarts to liters: multiply quarts by 0.95

Milliliters to ounces: multiply milliliters by 0.034

Liters to quarts: multiply liters by 1.057

Ounces to grams: multiply ounces by 28.3

Grams to ounces: multiply grams by .0353

Pounds to grams: multiply pounds by 453.59

Pounds to kilograms: multiply pounds by 0.45

Ounces to milliliters: multiply ounces by 30

Cups to liters: multiply cups by 0.24

Index

More Hot Cookbooks
by Hugh Carpenter & Teri Sandison

Fifty bold and sophisticated yet easy stir-fry recipes seasoned with a host of exciting ingredients. Perfect ideas for fresh, healthy weeknight meals or weekend entertaining. Includes more than 50 vibrant color photos.

Fifty wild and zesty recipes that combine chicken with the distinct flavors and cuisines of the world. Discover delicious and elegant ways to serve one of the most versatile and healthy meats. More than 50 color photos provide dramatic presentation ideas.